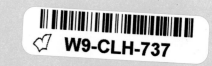

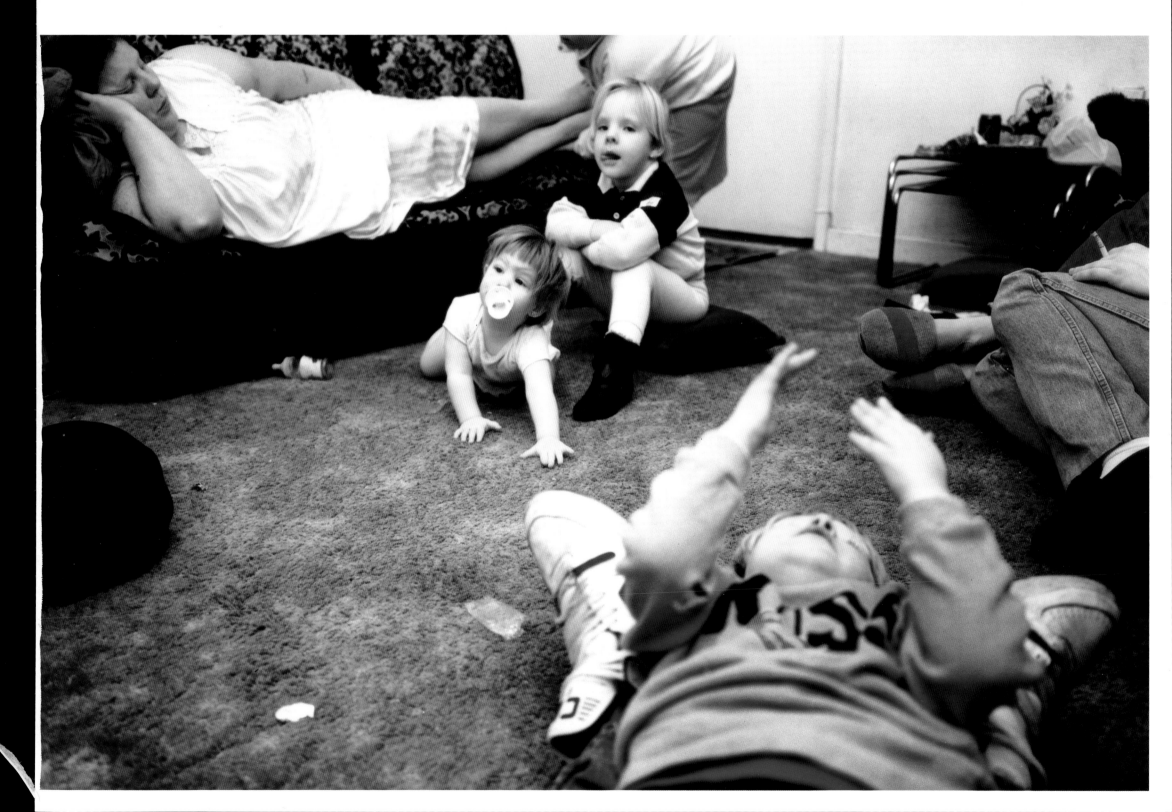

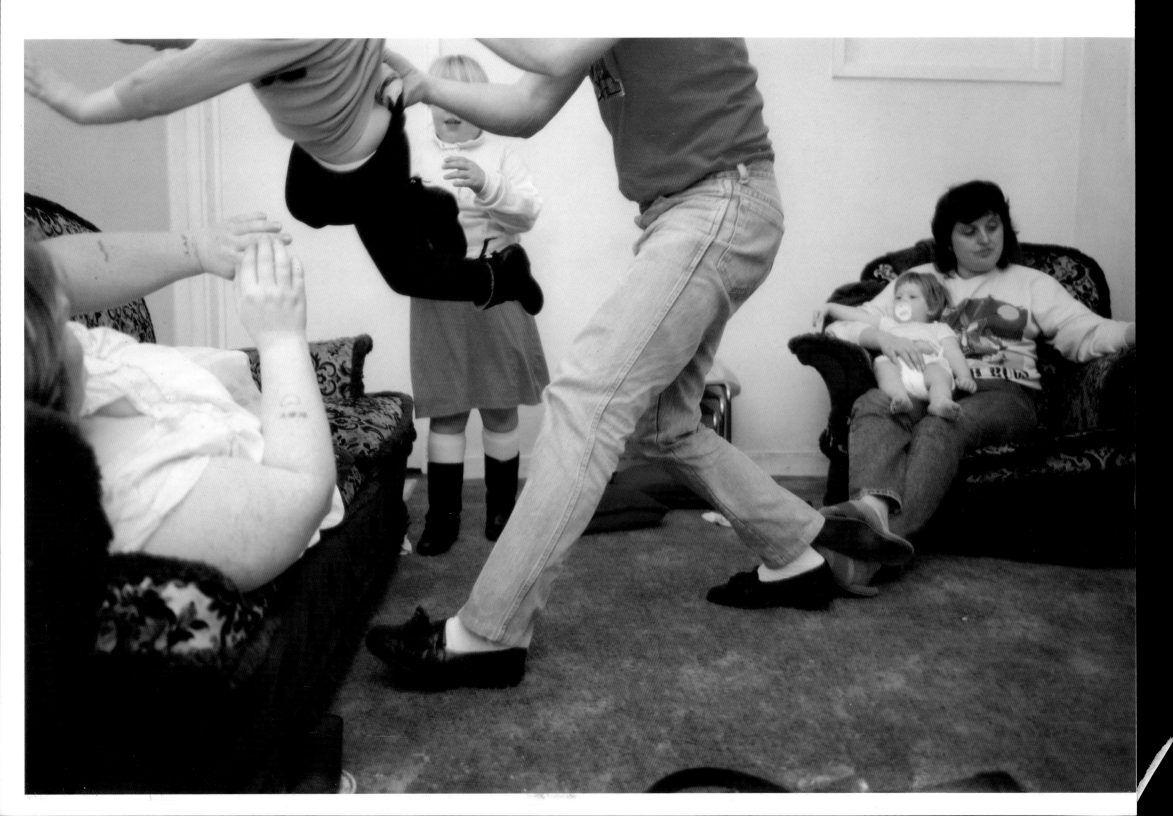

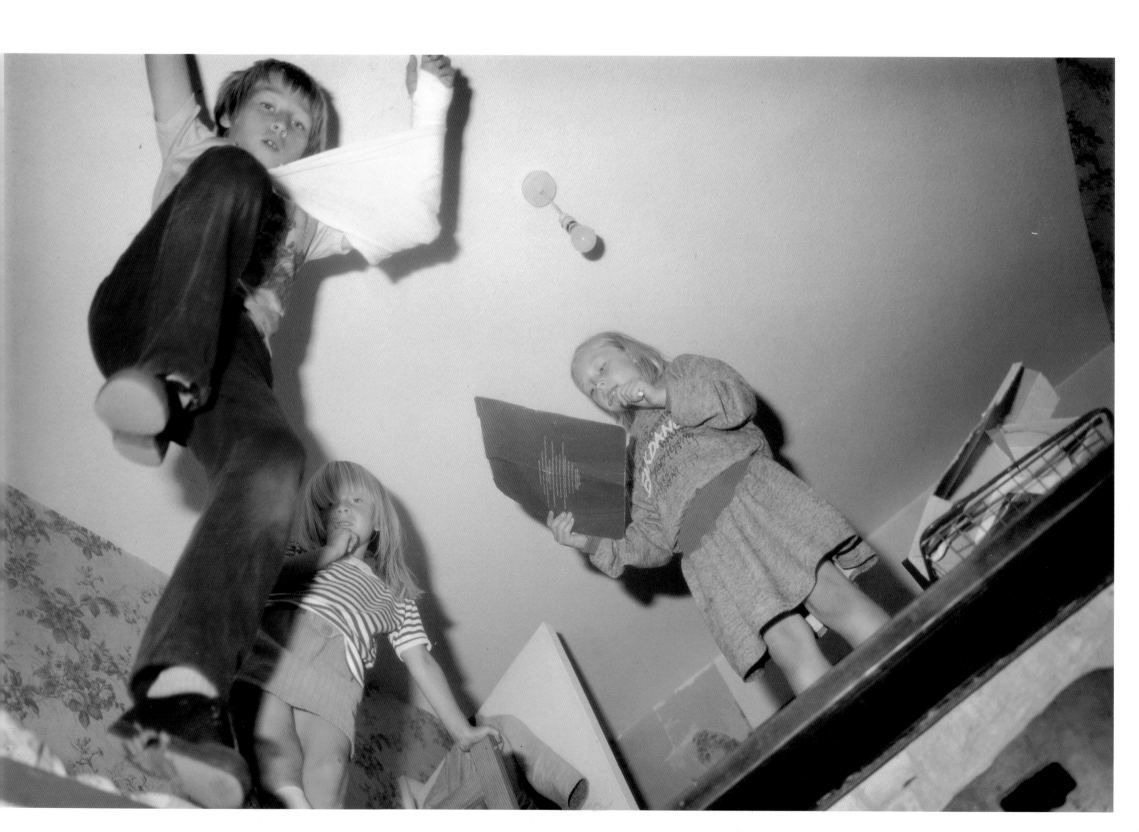

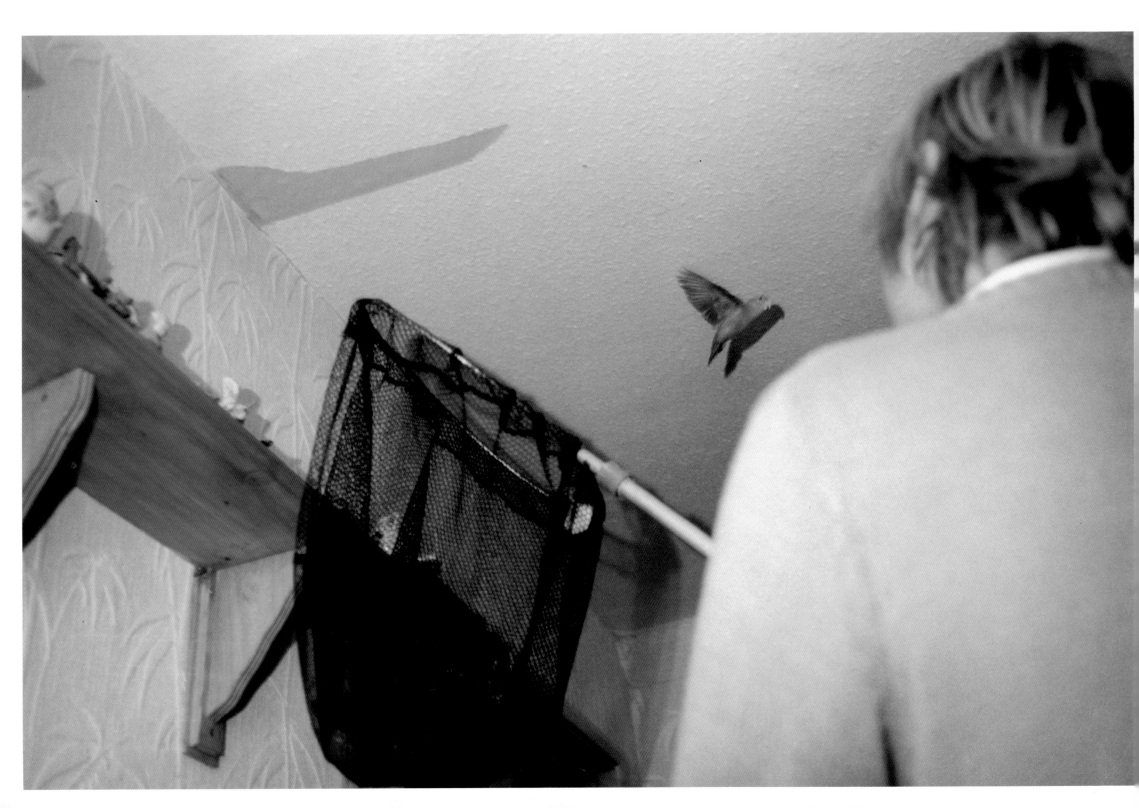

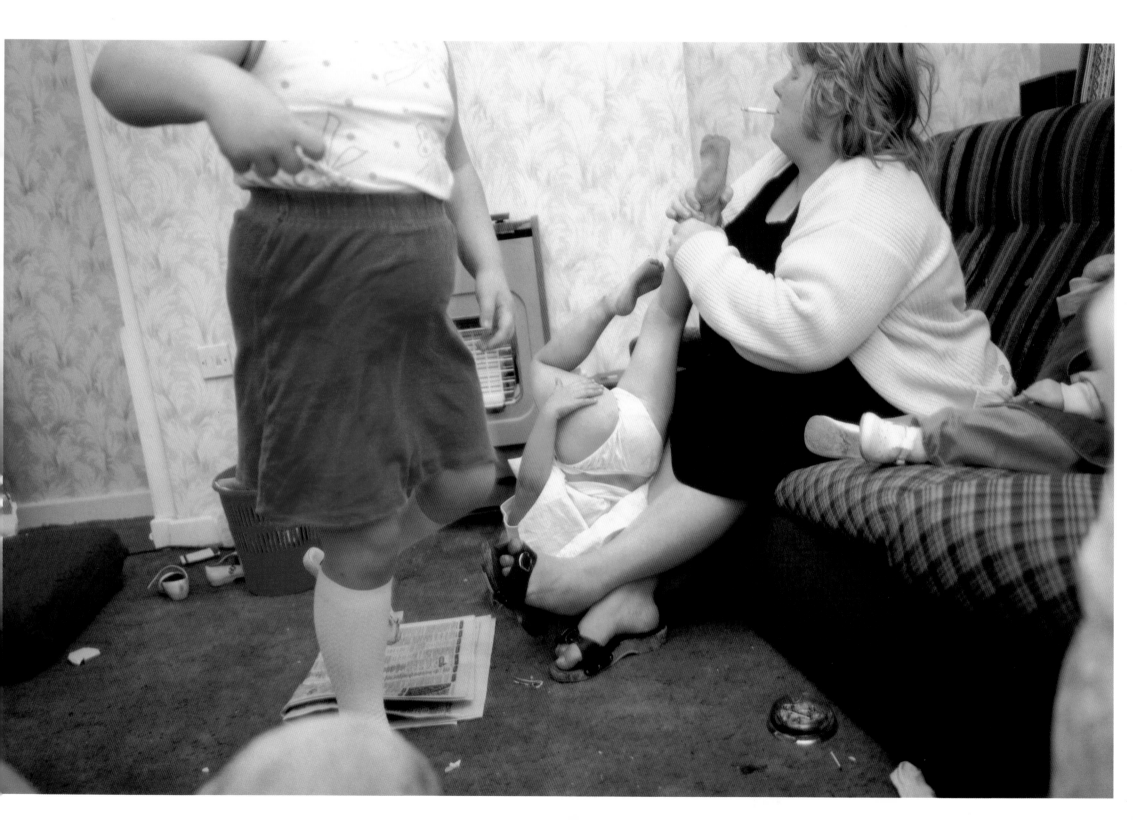

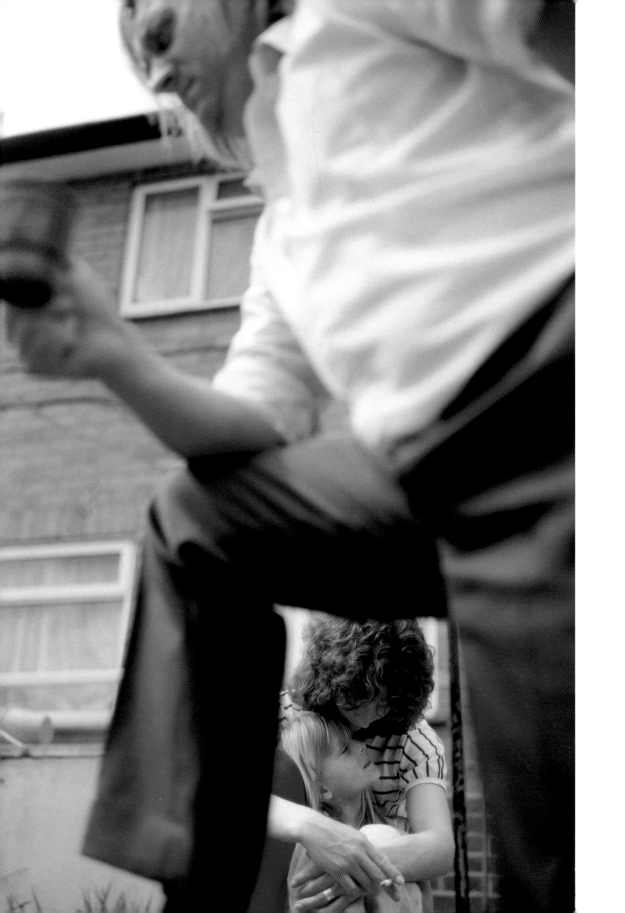

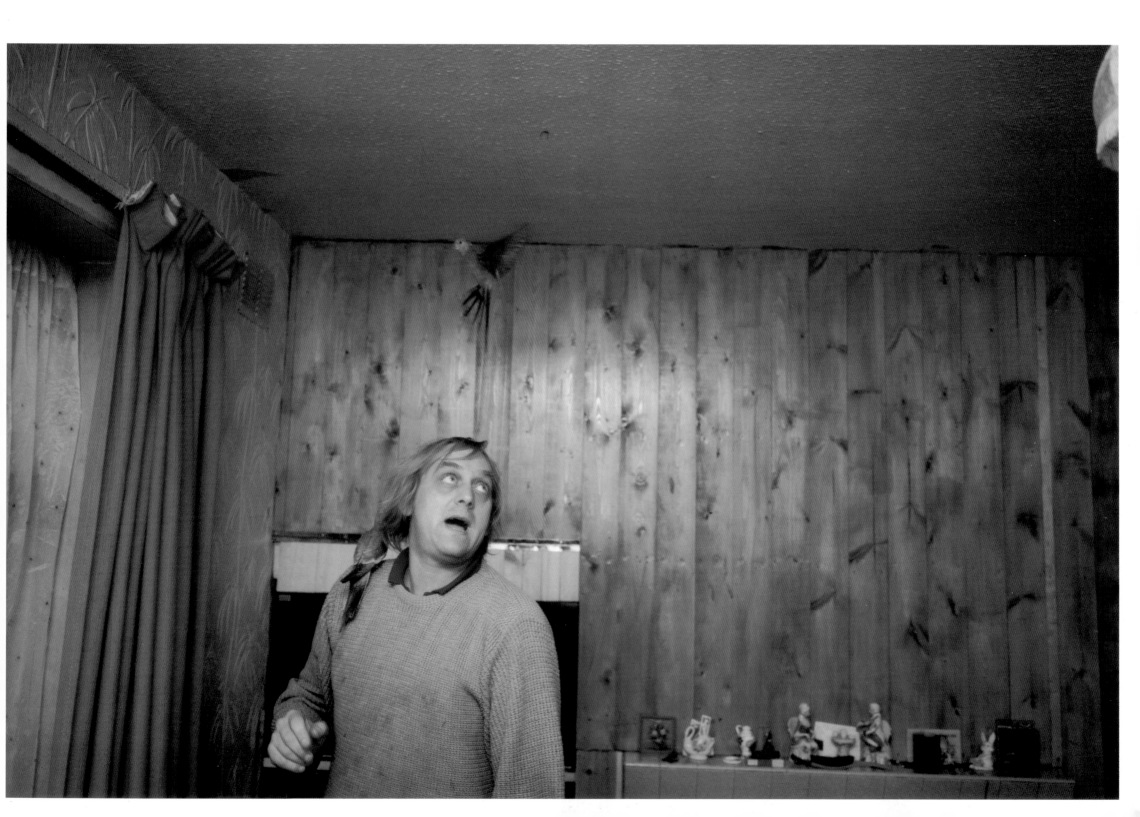

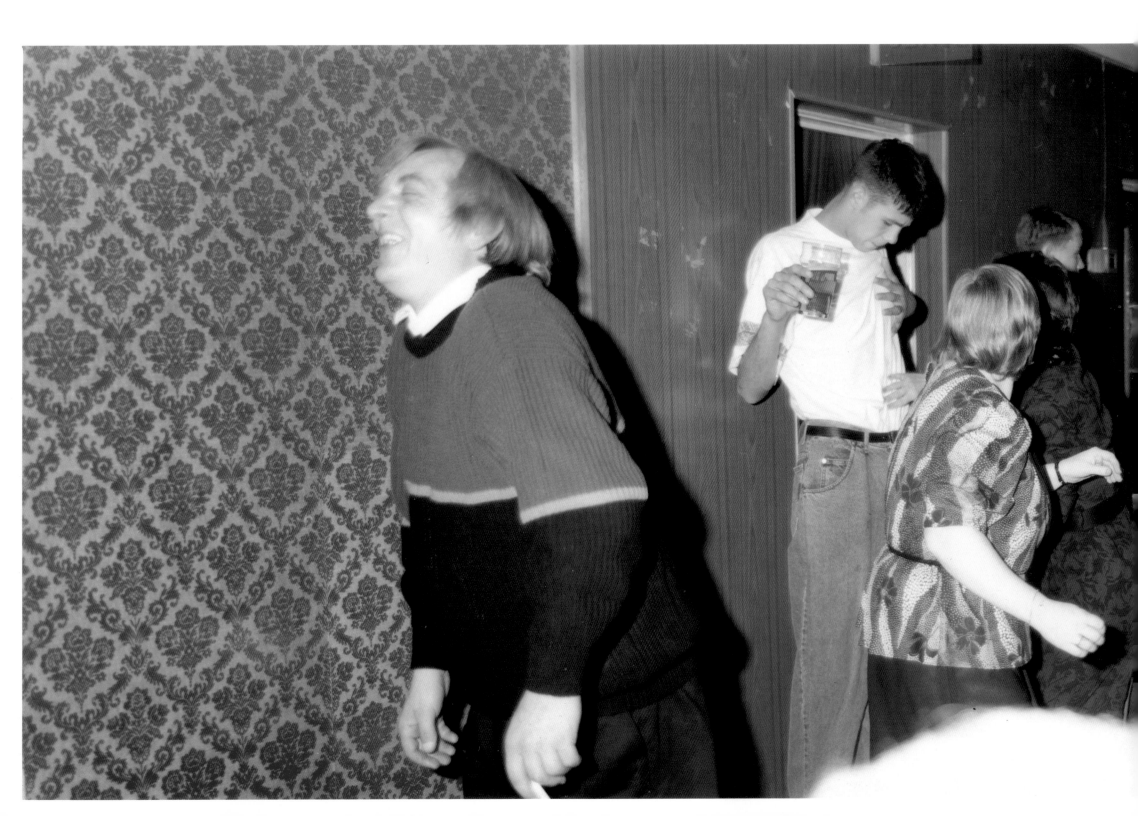

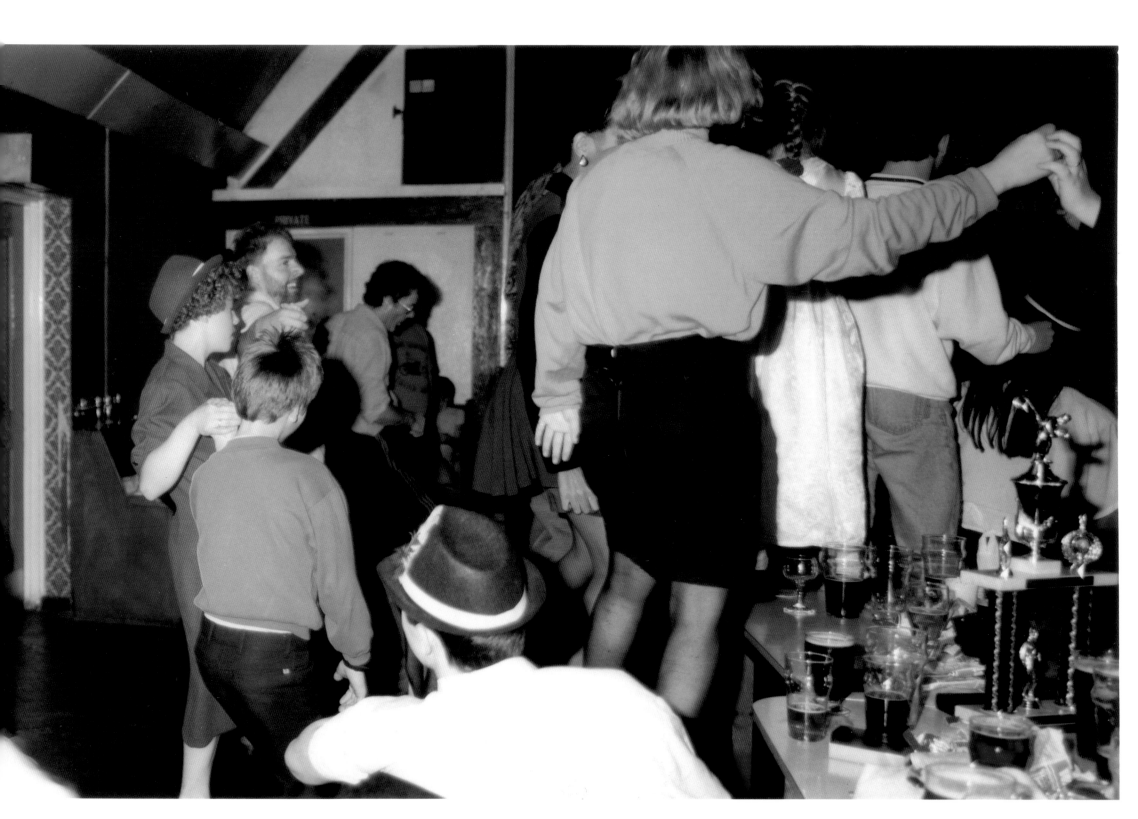

Living Room

Nick Waplington

Essays by John Berger and Richard Avedon

An Aperture Book

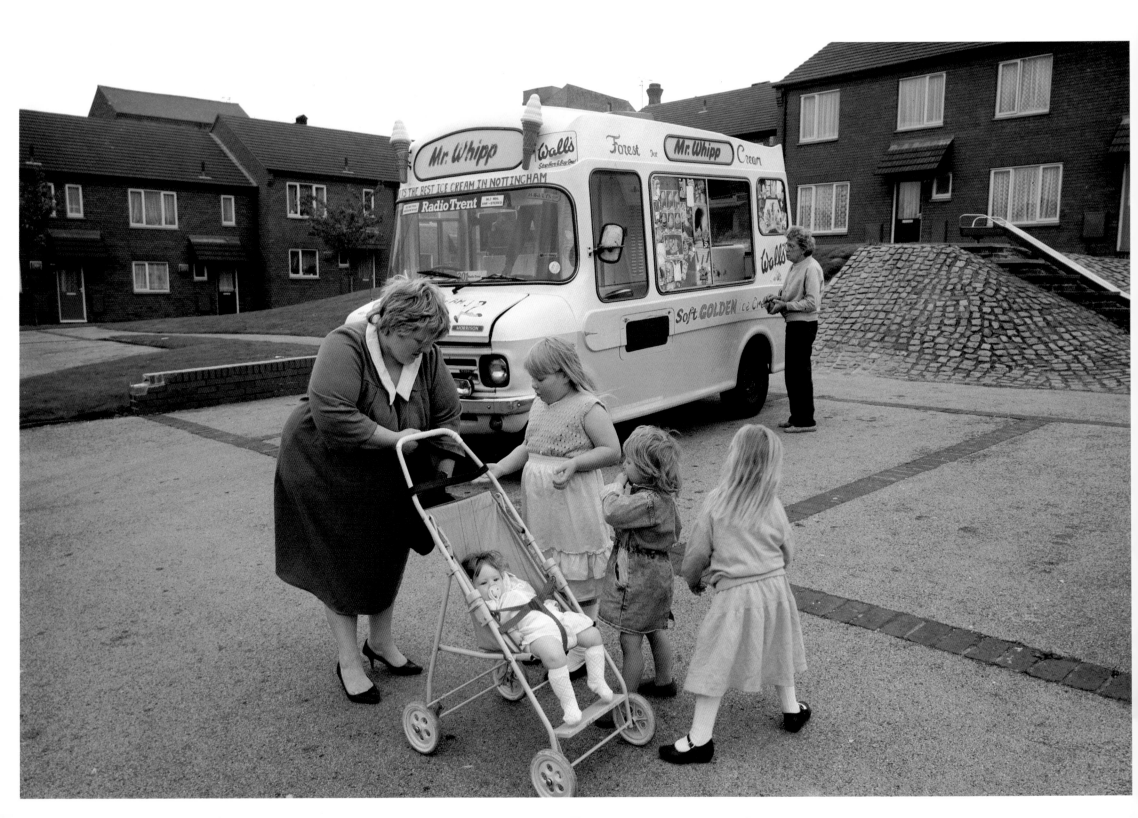

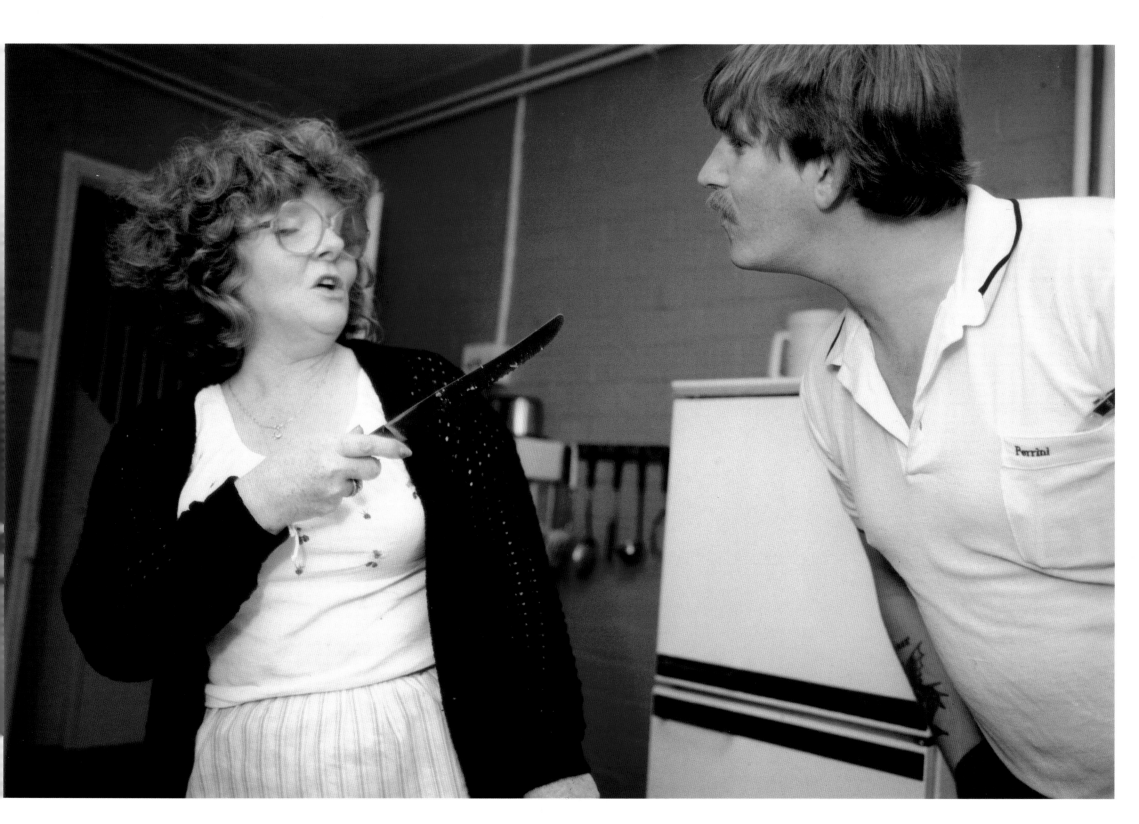

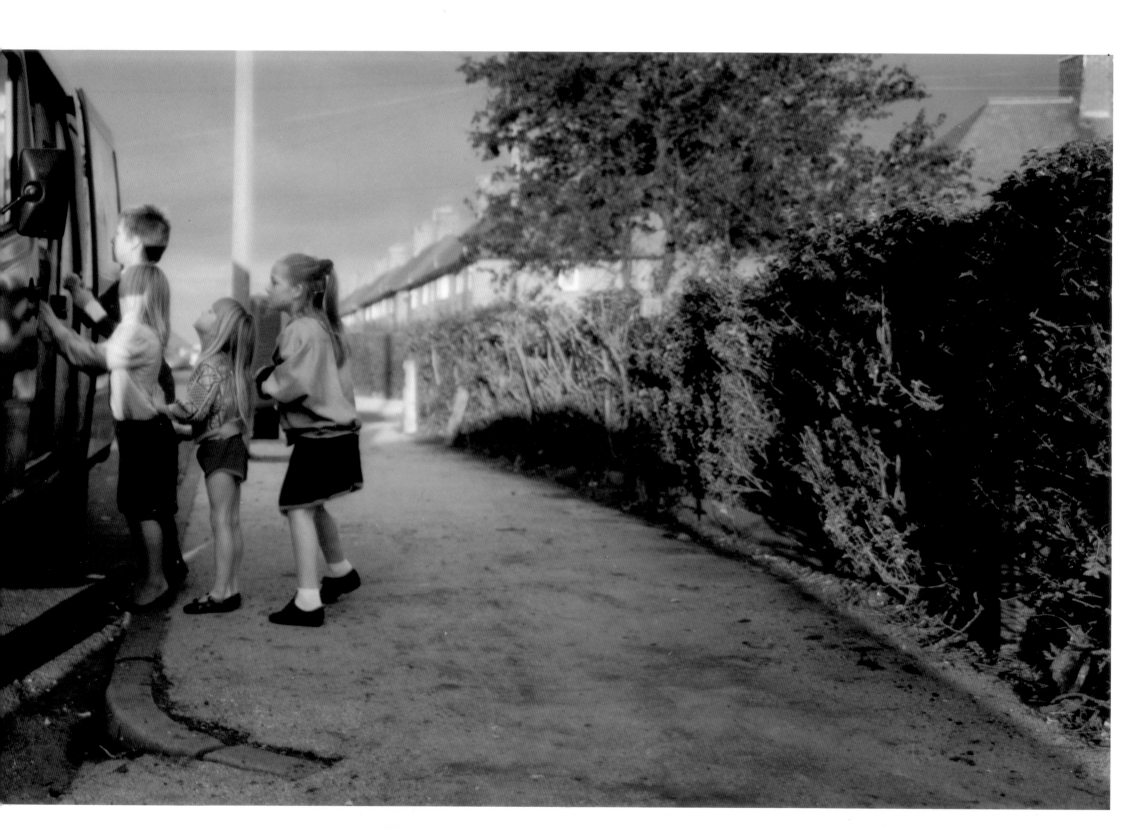

Means To Live

You seen our photo album anywhere?
 Last time I saw it, it was on the floor by the bed.
I looked everywhere in the bedroom--
even in the wardrobe.
 Never seen--
So many shoes in your life. I know!
Try by the telephone directory?
 I did.
Could be under the sofa.
 A pair of Nick's sneakers, that's all.
You've got shoes on the brain, you have.
Go in the kitchen.
On top of the cupboard,
I put things up there sometimes--
out of reach of the kids...
 Three <u>National Geographic</u> magazines,
 one <u>Radio Times</u> and a map of Spain,
 but no photo album.
 Sure you didn't lend it?
Who should I lend it to?
 I'm asking...
Ah! What do you know?
Yes, yes, I remember now, went
clean out of my mind, last Monday--
 You lent it to your Mum!
No, no, not at all. It was Nick.
Nick said he needed it.
He said he'd bring it back but he needed it to make a choice.
 I could tell him the best ones.
 They leap out, to my mind, the best ones.
He's going to show us the ones he's choosing.
 The Polaroids that go skewy, Mum, I love those.
I like the one where I'm flying.
 We're going all over the world, all of us!
In a caravan?
 In a book of photos, Heartbeat.
I don't like it when you call me Heartbeat.
 There'll be one picture of you in the bath!
You're joking, I can see by your eyes you're joking.
 It's for real.
Us really for real?
In a book!
 Well, just so long as Nick brings our album back...

What is remarkable about Nick Waplington's photographs is the special way in which they make the intimate something public, something that we, who do not know personally the two families photographed, can look at without any sense (or thrill) of intrusion. Countless photographs violate the intimate simply by placing it in the public context of a book, a newspaper, a TV slot. Yet others--like most wedding photographs--make the intimate formal and thus empty it of its content.

It is obvious that Nick (the photos make me want to call him by his first name), that Nick knows and loves the friends he has photographed. Obvious because of the way they don't look at him. Sometimes, I guess, they were aware that he was taking a picture (yet another one!), but they were aware of it as they might have been aware that he was smiling, and so he was happy and didn't have to be fussed over.

Other times, they forgot about him altogether. He was just there as naturally as if it were Saturday. No work on Saturday, no looking for work. Day off. Day for having fun. Day for watching football results on the TV. Day for letting the parakeets out of their cages during the halftime break. Day when Nick comes around.

It's not so obvious, but if you look carefully, you can tell that Nick took these photos over quite a long period of time. The reddish wall-to-wall carpet was changed in the living room. To the left of the back door in the kitchen of the other house, there used to be a kind of open cupboard made out of bricks: then Jeff changed it and put up a counter where you can sit, even eat if you want.

When you know them intimately, small houses grow up, acquire habits, create surprises, cause worries, change--not as insistently as the children do, but in their own do-it-yourself fashion. Similarly, Nick's photographs are not about captured moments. They are more experiential, constantly evolving over time, commenting on each other, alive. And always there is that thing he has seen, I think, unlike anybody else:

Pleasure. Not pleasure-seekers. Not luxury. Not ecstasy. Not fashion. Not innocence. But the untidy, crowded, noisy, jokey, sad, persistent, working-class pleasure of being at home on Saturday. It's not a pleasure that idealizes, for it's not a pleasure that looks at itself. It accepts sobbing and tiredness and the bills at the end of the month. It wouldn't exist without pats, slaps, tickles, tears, cuddling up--and what the dictionaries call affection, which is really what body offers body for consolation and confirmation with the knowledge--whatever the doctors and the ministers and the Department of Employment say--that eyes are windows onto a soul.

Taken during those years in Britain (as in the U.S.) when the greed of the ruthless class was impoverishing millions of other people's lives--you can read the signs of the consequent impoverishment in this book--these photos are nevertheless not icons of poverty, but, rather, painted cupolas of play.

Make her hair stand up straight with the vacuum cleaner! Feed the lion!

Splash! Eat the slipper! Lovey-Dovey! Fly jet! Ice cream. I scream! Lollapaloosa! Cupolas of games. Shared games, which flare, impertinently and gloriously, against the dark. The sacred canoodling pleasure that grows from the flesh of my flesh.

An artist's vision can never be defined just according to what he or she has seen--how he has seen is equally important. Waplington had to discover how to make not records, but images of his chosen subject matter. He had to create images of pleasure to match his subject.

And this is why I think of cupolas. His images are the next-door neighbors to those of baroque ceiling painting--and, in particular, to the work of Peter Paul Rubens. There is an extraordinary affinity of color, pose, gesture, framing, composition; above all, of the way in which figures relate spatially to one another--look at the three girls and the neighbor in the kitchen, look at the father holding his daughter upside down, or the children on the sofa and the uncle smoking, look at the magic of the vacuum cleaner. I could find bodies of putti, men, women, touching, twisting, moving, painted by Peter Paul, to match every one of these. Sometimes they would be almost identical. We could play "spit" with them all Saturday afternoon.

But it would be only an art-historical game, for the matching is not really important. When Nick took his pictures he wasn't thinking of Peter Paul, and there's little in common between the biographies of the Flemish prince of painting and this kid from Nottingham. The only thing they have in common is a genius for saluting pleasure and a baroque enthusiasm.

I don't know how Nick's notion of using a 6 x 9 camera first came to him. But the baroque was already in this idea. It is a camera designed for panoramic topographical studies. When applied to small interiors and close-up figures, the forms photographed have the space to expand, to become landscapes, or even firmaments. And this is very close to the baroque principle. Baroque wanted to turn the earth-bound into the celestial, and to make human figures appear as at home in the sky as on the ground.

Nick, of course, does not have a sixteenth-century view of the celestial; he has friends in Nottingham. Yet to give expression to the energy of the pleasures of these friends, he needed the visual dynamic of the baroque. And with the help of this camera, he has recycled it.

Any dynamic image begins with what is so dully called composition--how the frame is filled, not just with forms but with movements, and with how these seduce our perception. For example, in the picture of the daughters feeding their father on the kitchen floor: Nick deliberately printed it in reverse (all three appearing left-handed) because like this, the girl on the left takes our hand and leads us with her feet into the picture, as she could never do if she was on the right.

For example, in the flying picture, Nick was lying on the floor because otherwise there would have been no height and the beige ceiling could never have become gold.

For example, in the living room, where the mother is on the sofa and the girl is licking the corner of her mouth; if Nick hadn't put his big feet in it, there'd be no magic circle but just a fragment of a Saturday.

Yet, finally, what is original and moving about Waplington's vision transcends his choice of camera and his skill in composing. I'm talking about his awareness of what is outside the frame. Turning the pages of this book, we also watch the invisible. The paradox of photography is that all great photographers lead us to do this. The invisible has many departments and many moods.

Living Room is in fact a biography of two families in Nottingham. We see them mostly on Saturdays, but we imagine them on every other day of the week; we imagine them in history, which today again tries to treat them like shit; we imagine them all as children; we imagine them all growing old. Each picture holds those whom it shows, as a family name holds forever the one to whom it has been given. Aunt Elsie is always Aunt Elsie. Dad is always Dad even when he's a granddad. Now we call Mum Mum even when she was a little girl.

The opposite of instant pictures, these photos are as lasting for a lifetime as tattoos, yet all they show are split seconds. This is because, brought there in the concentration of Nick's love, life breathes through every one.

Do you think people'll look at us, Dad? Don't ask me.

Yes, they will. For a very long time. Walt Whitman, who lived before any of us were born, knew why:"I am the poet of the Body and I am the poet of the Soul, The pleasures of heaven are with me and the pains of hell are with me, The first I graft and increase upon myself, the latter I translate into a new tongue. I am the poet of the woman the same as the man, And I say it is as great to be a woman as to be a man, And I say there is nothing greater than the mother of men."

Here is what it means to live. As I write in the early weeks of 1991, I know that here is what is reduced to dust when bombs are dropped on cities. Be it Nottingham, Baghdad or New York.

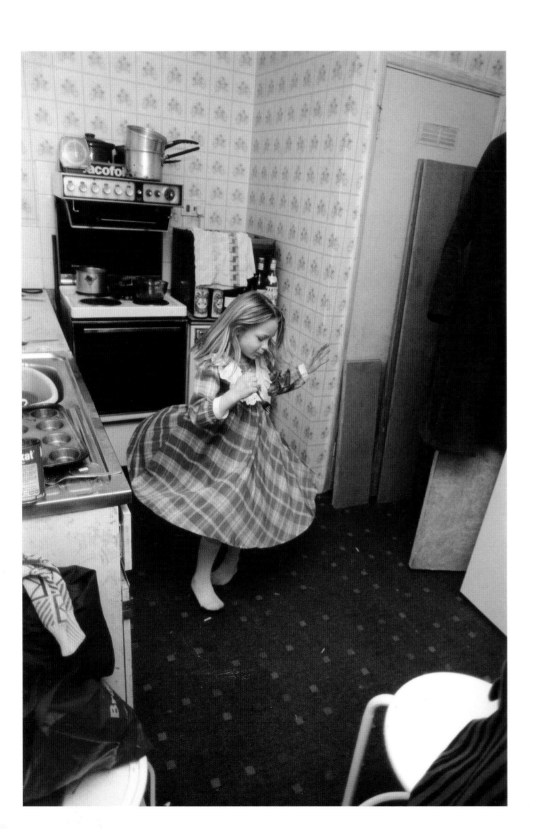

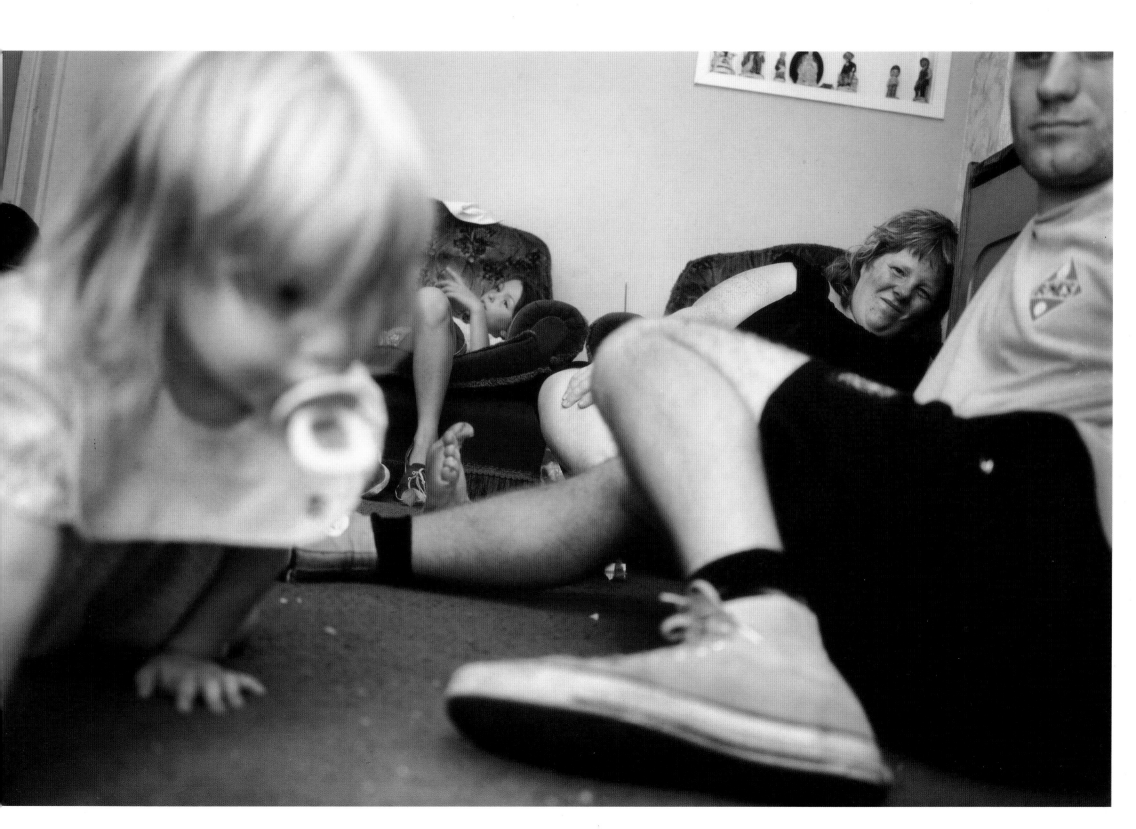

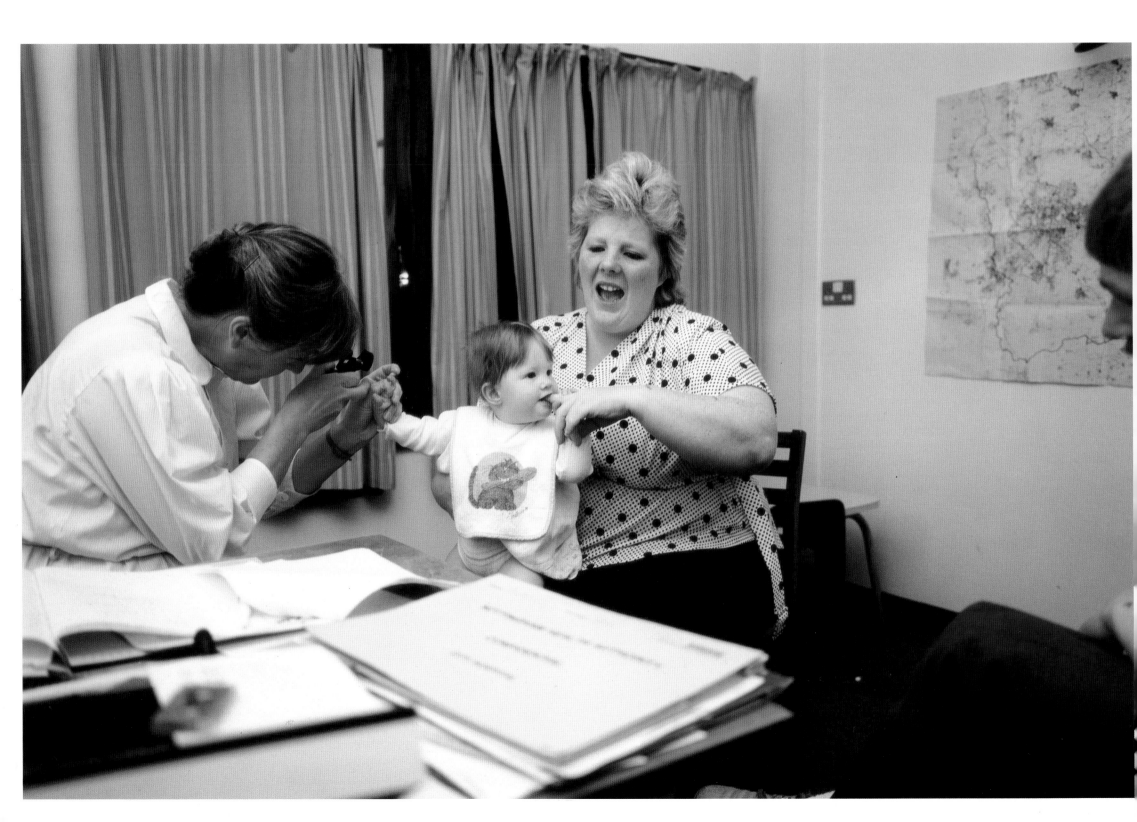

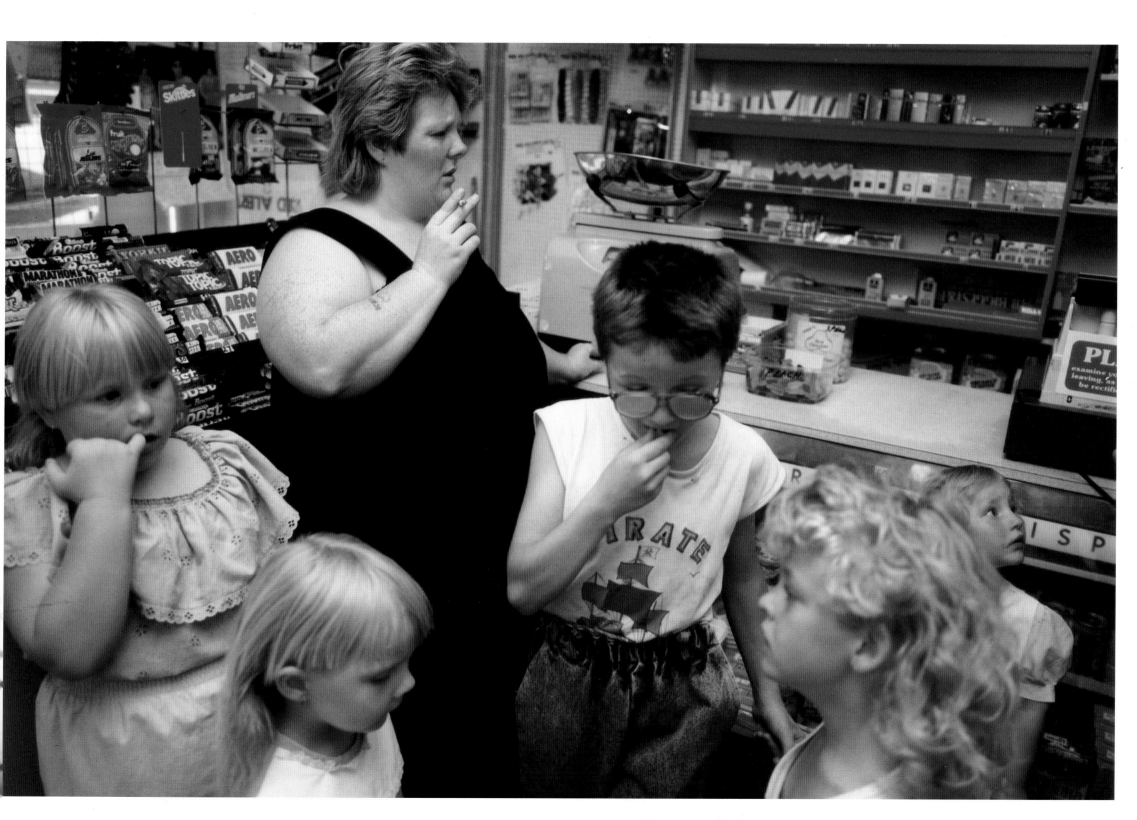

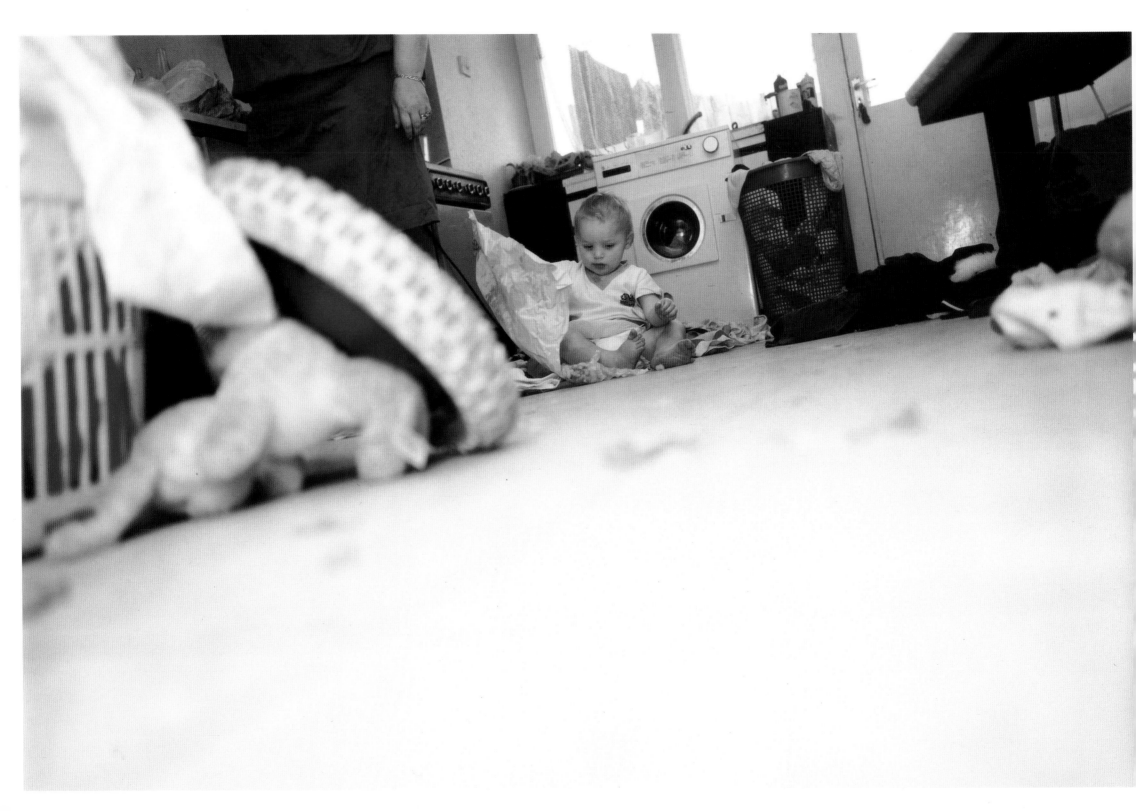

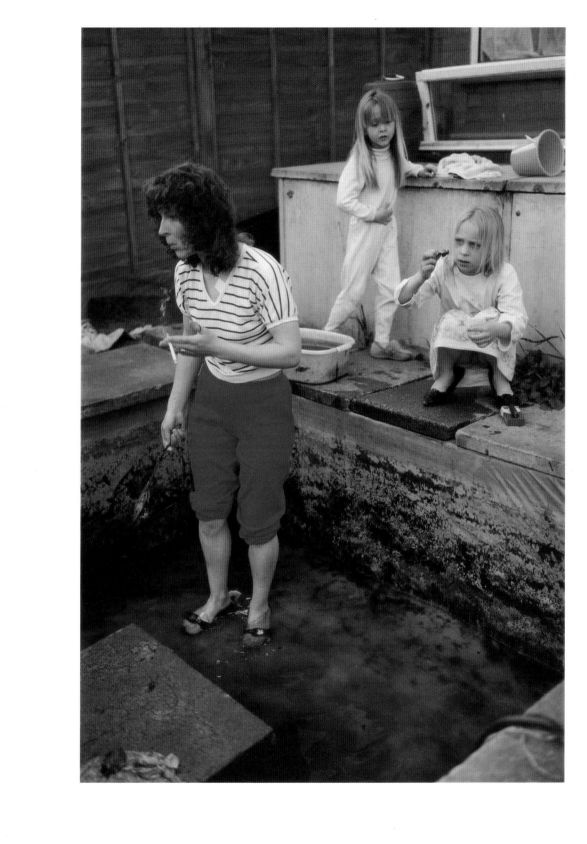

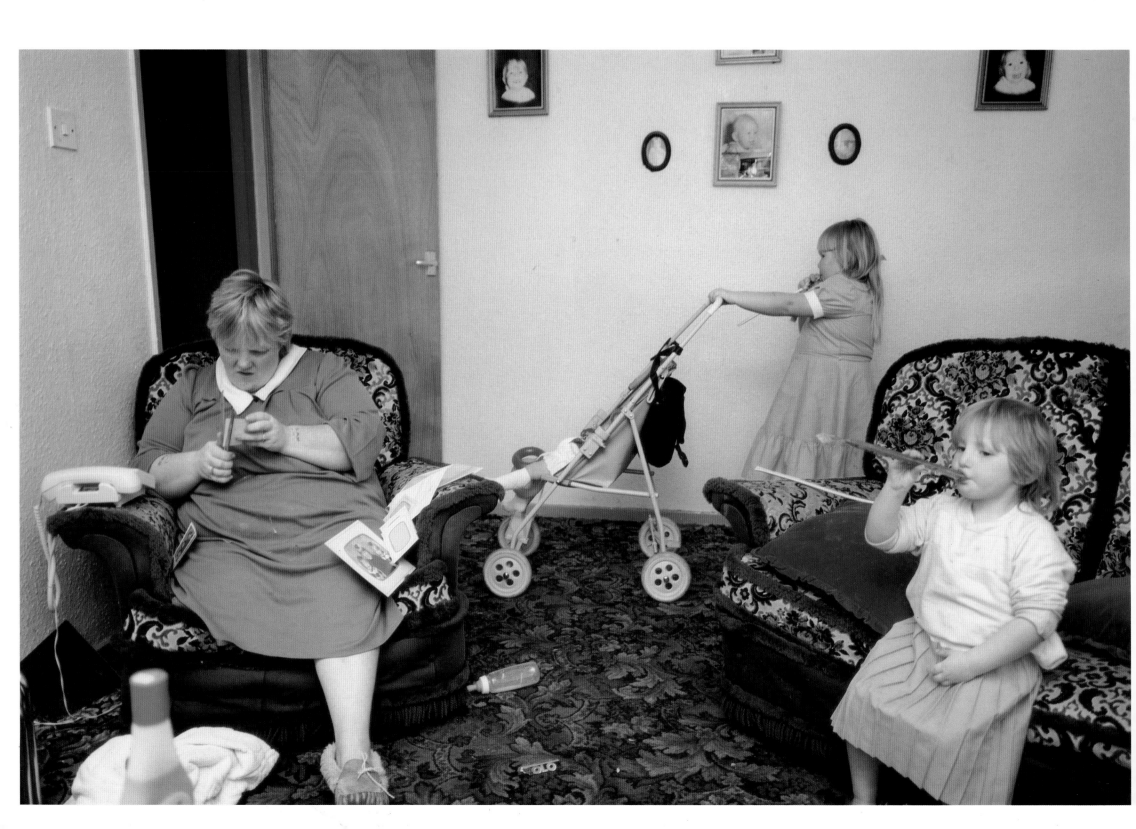

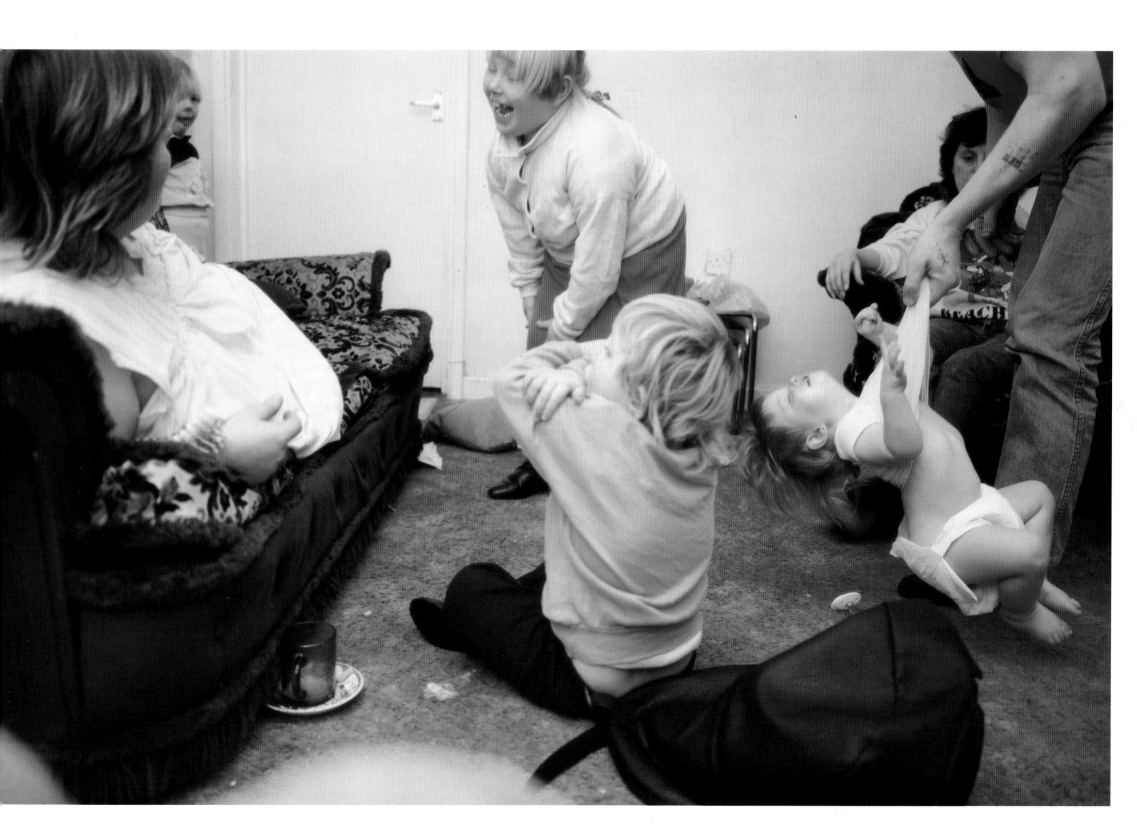

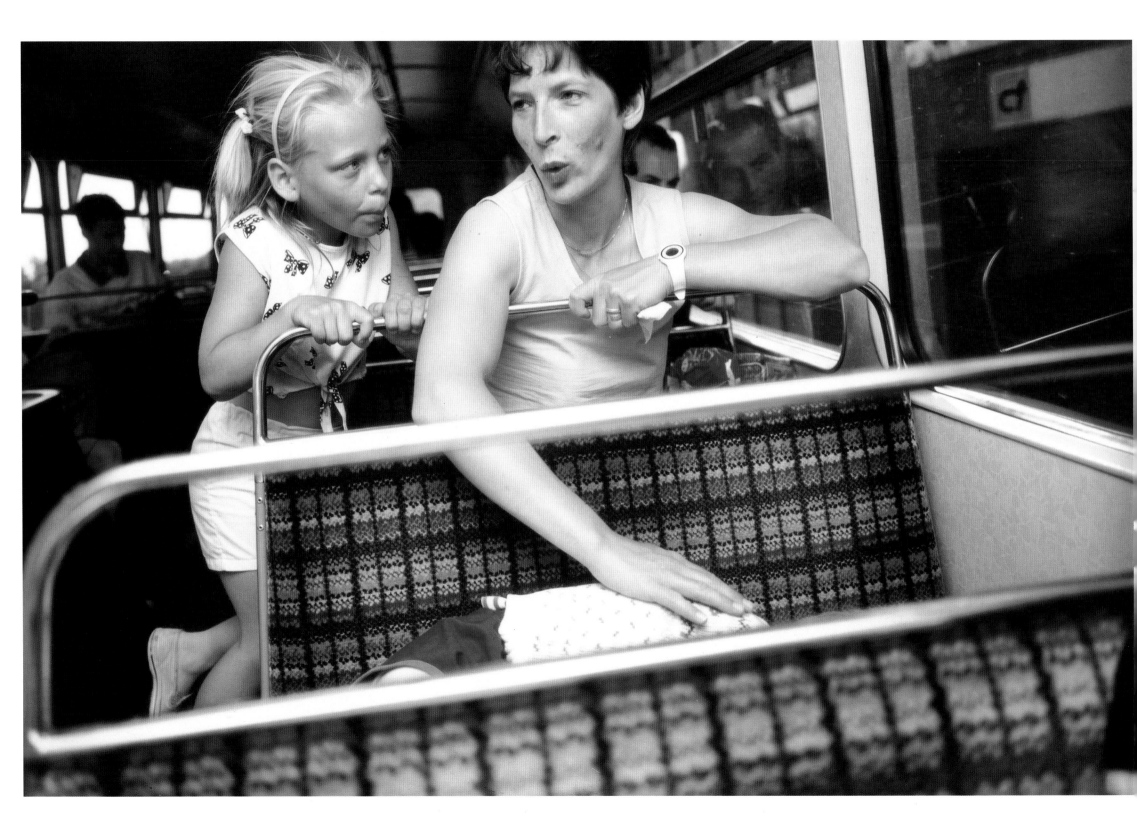

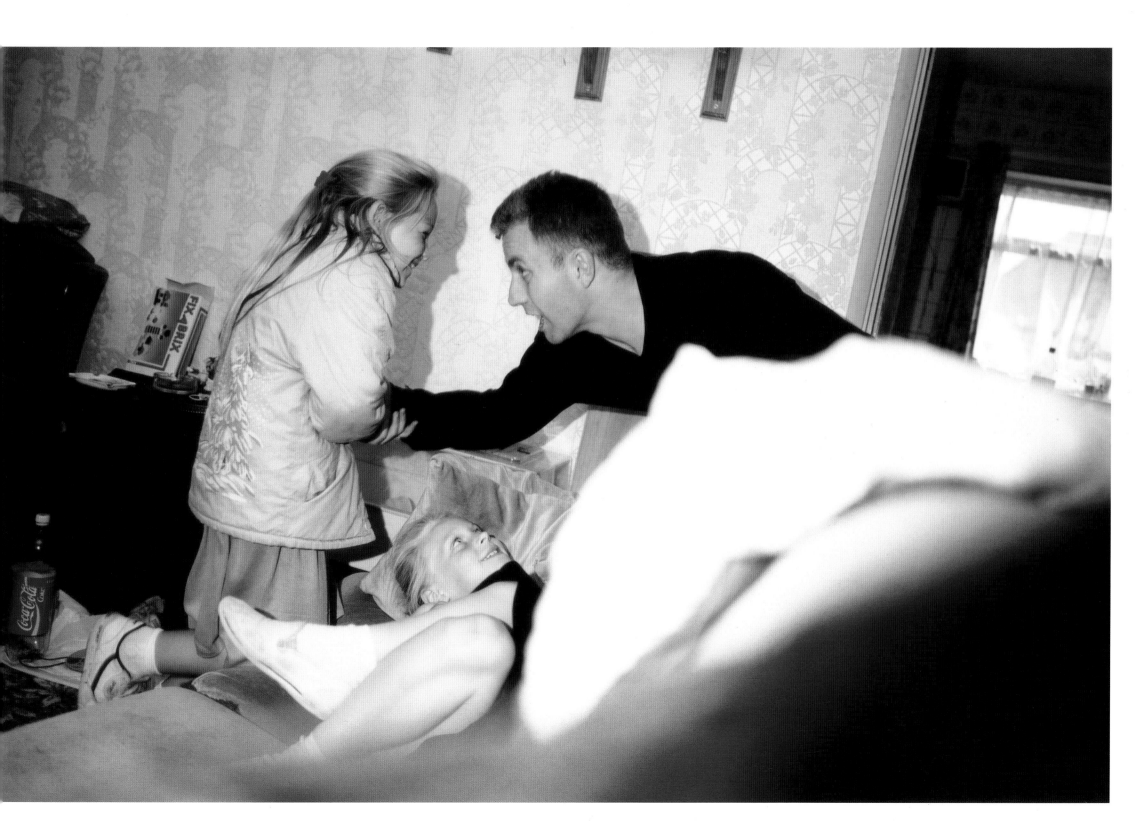

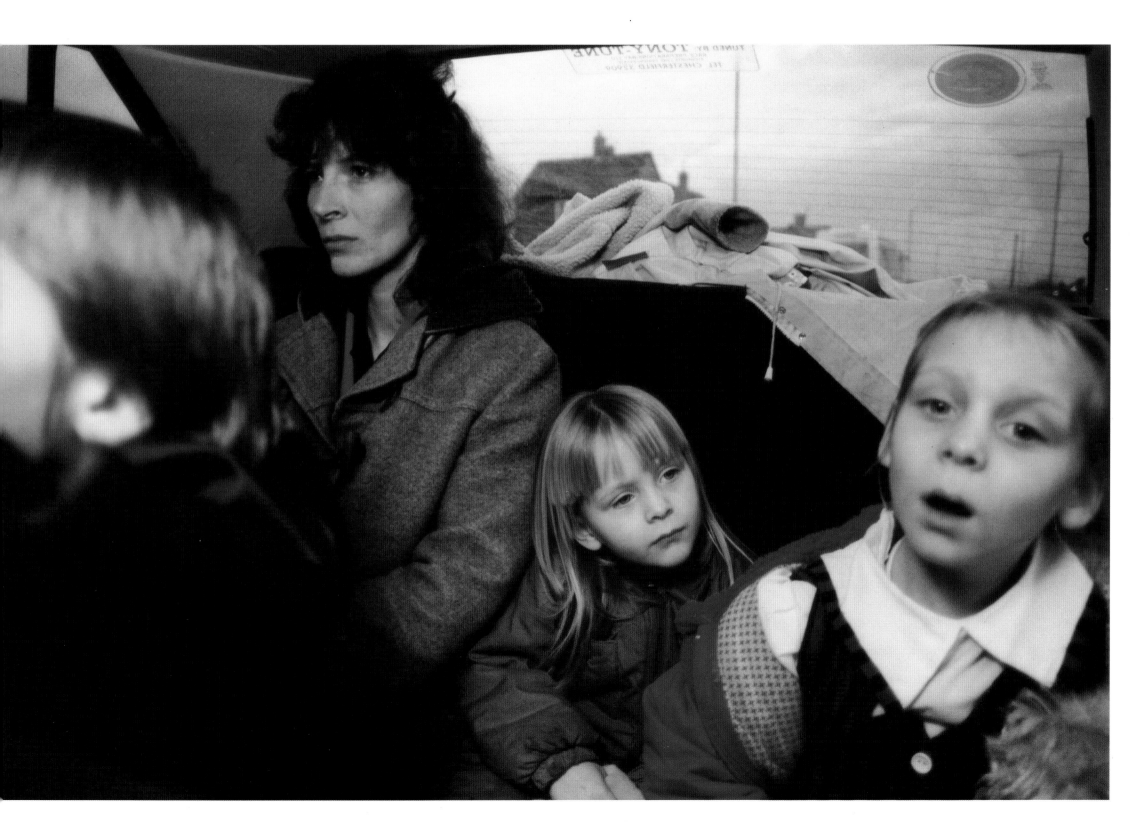

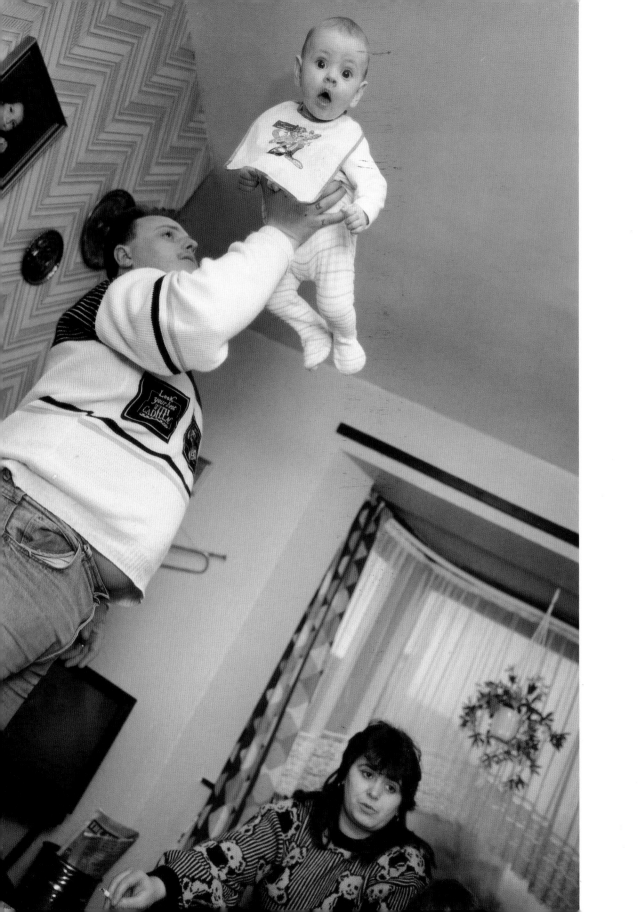

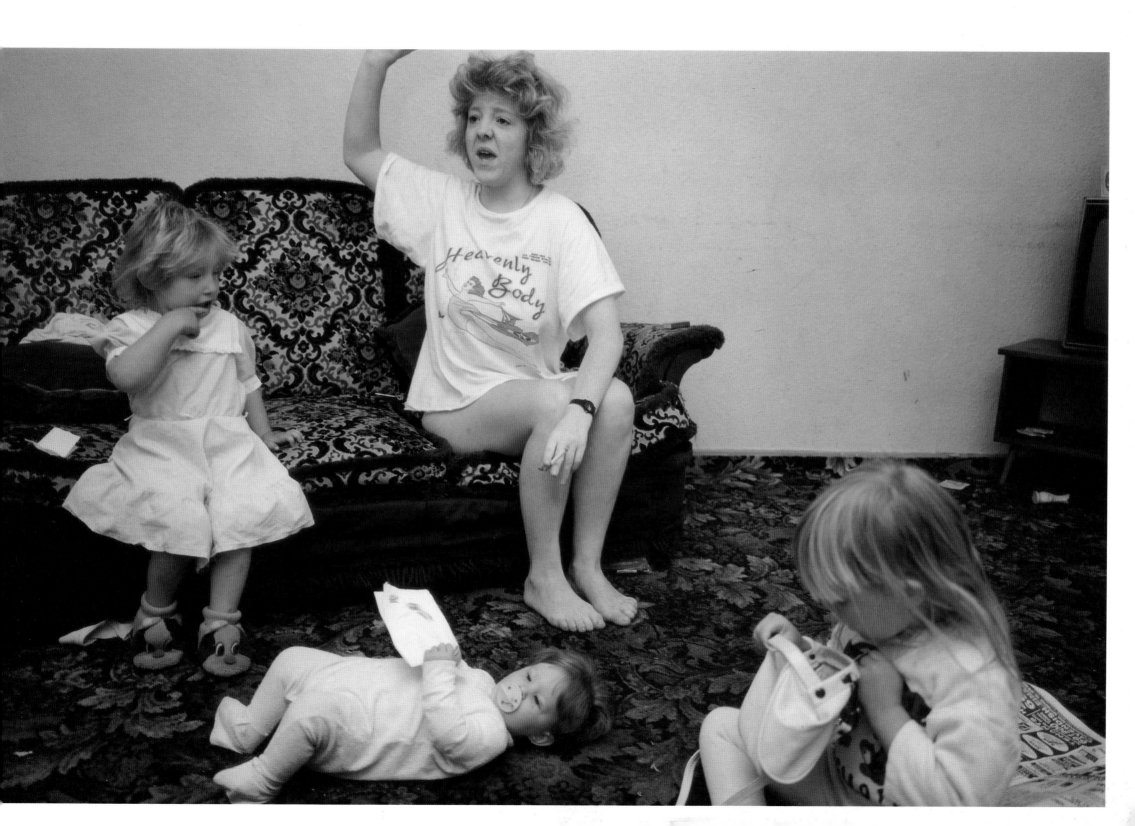

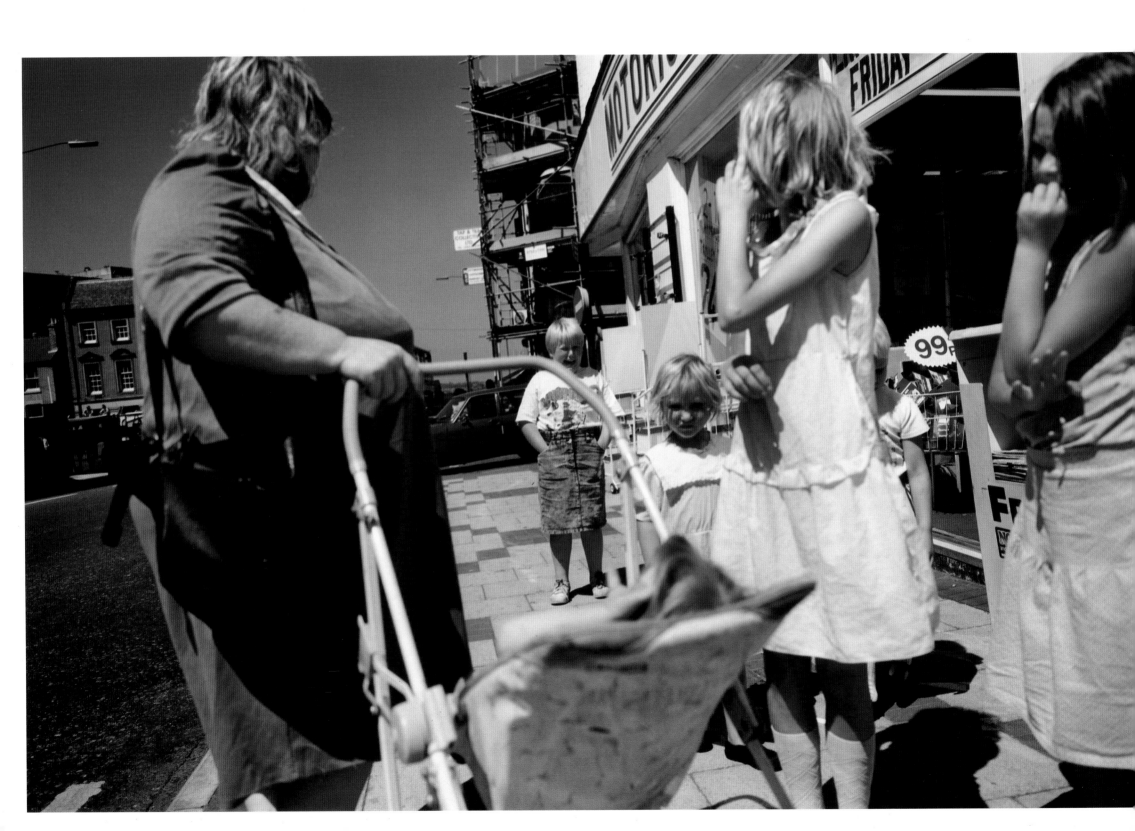

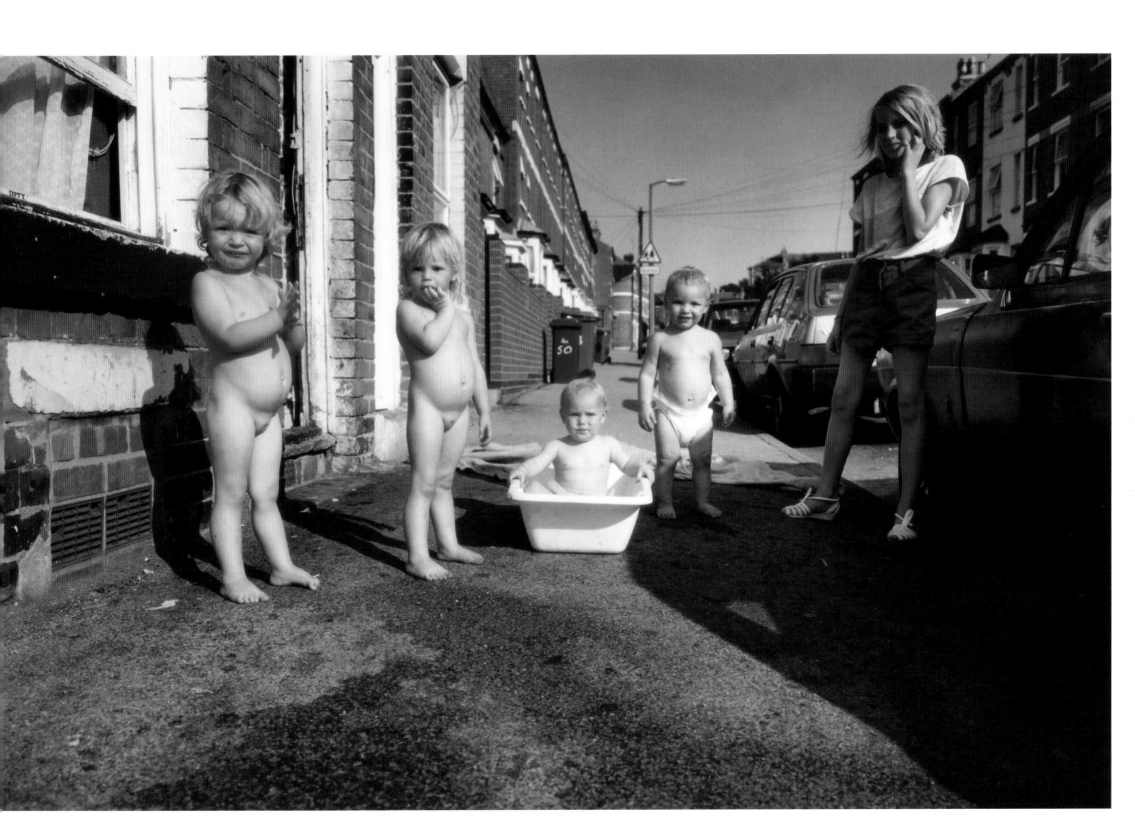

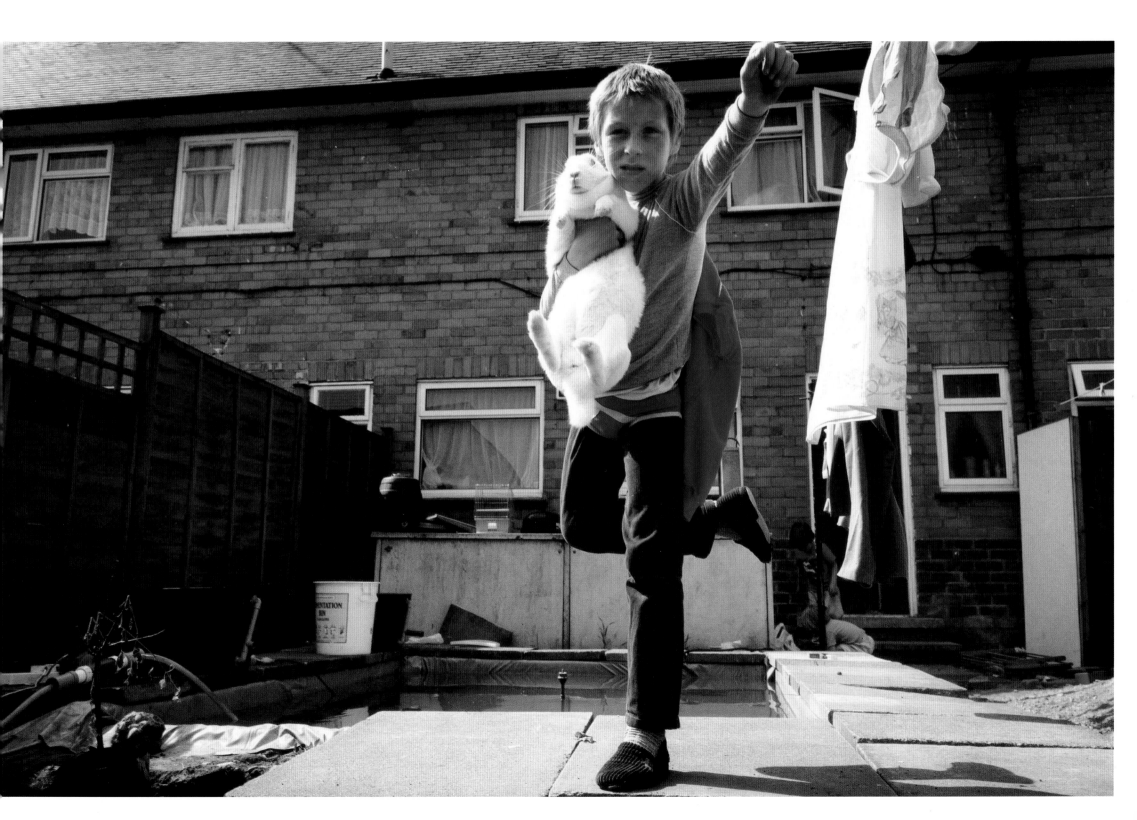

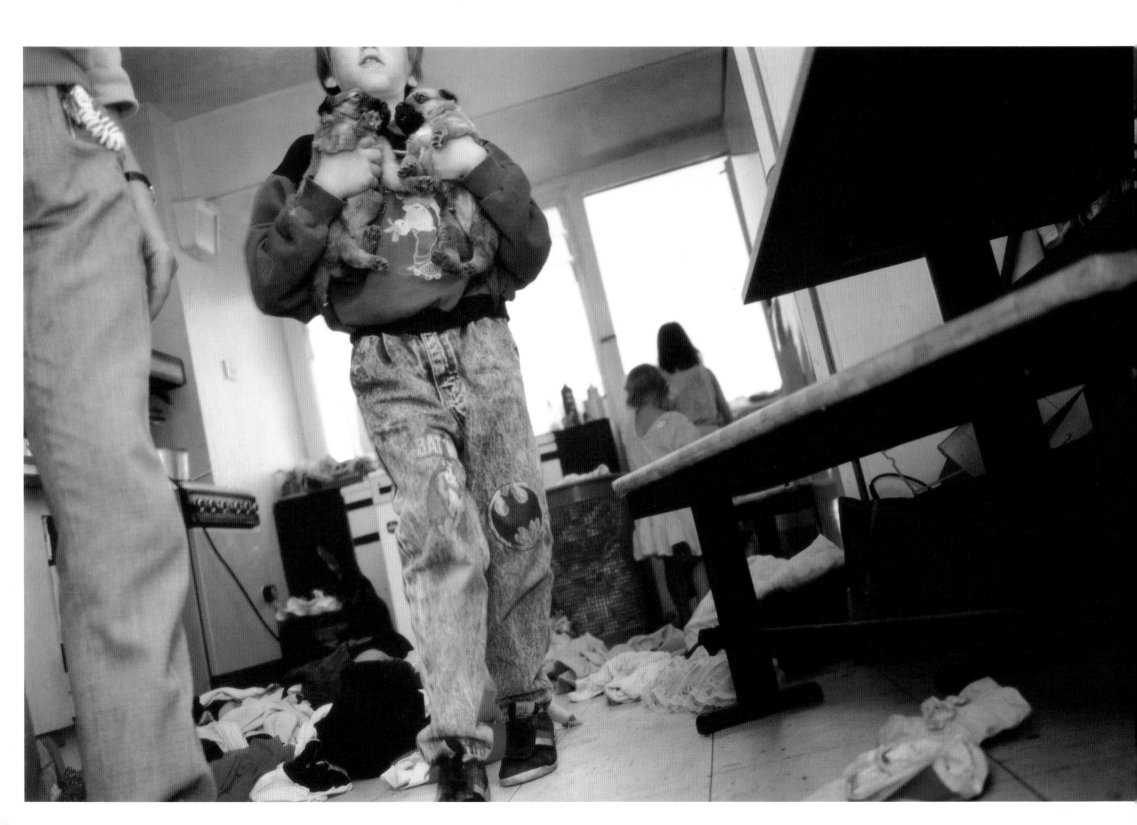

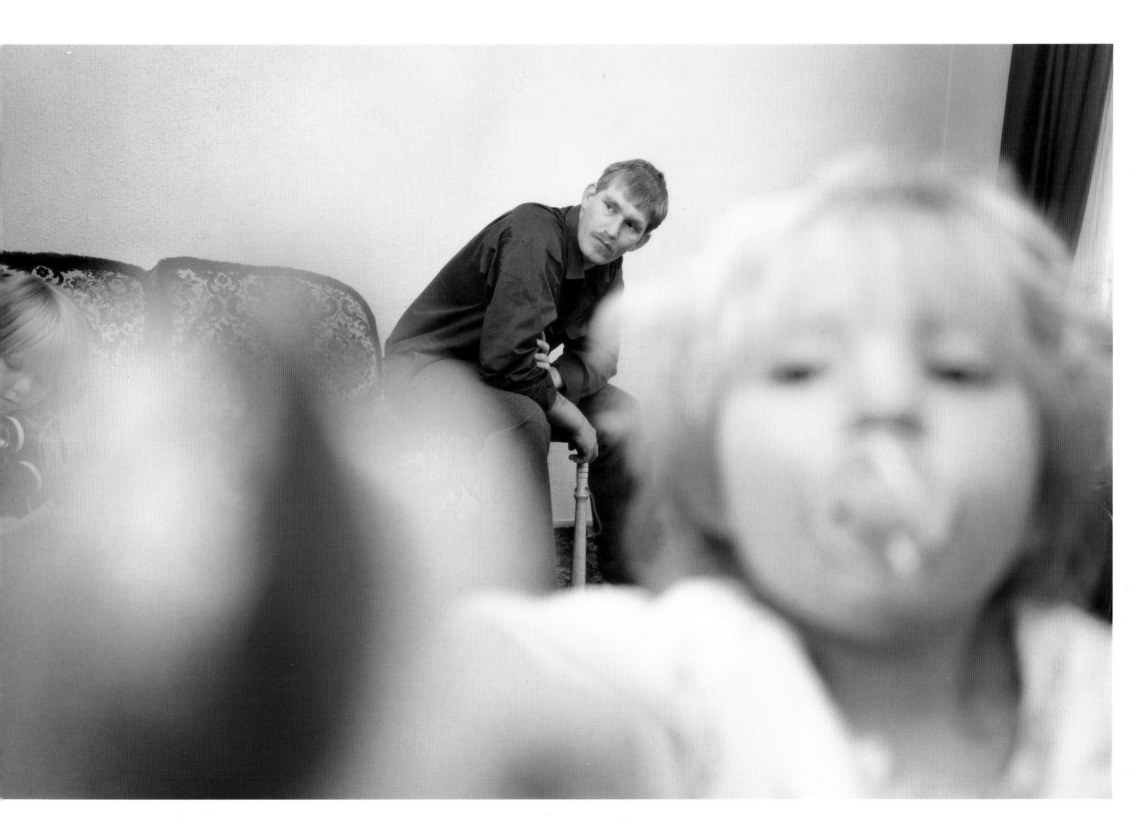

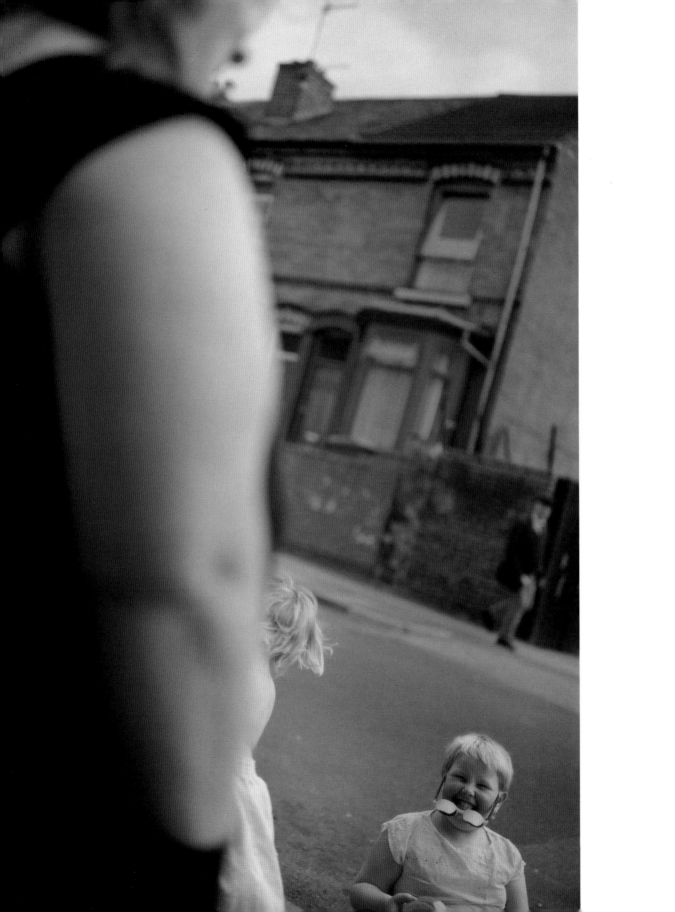

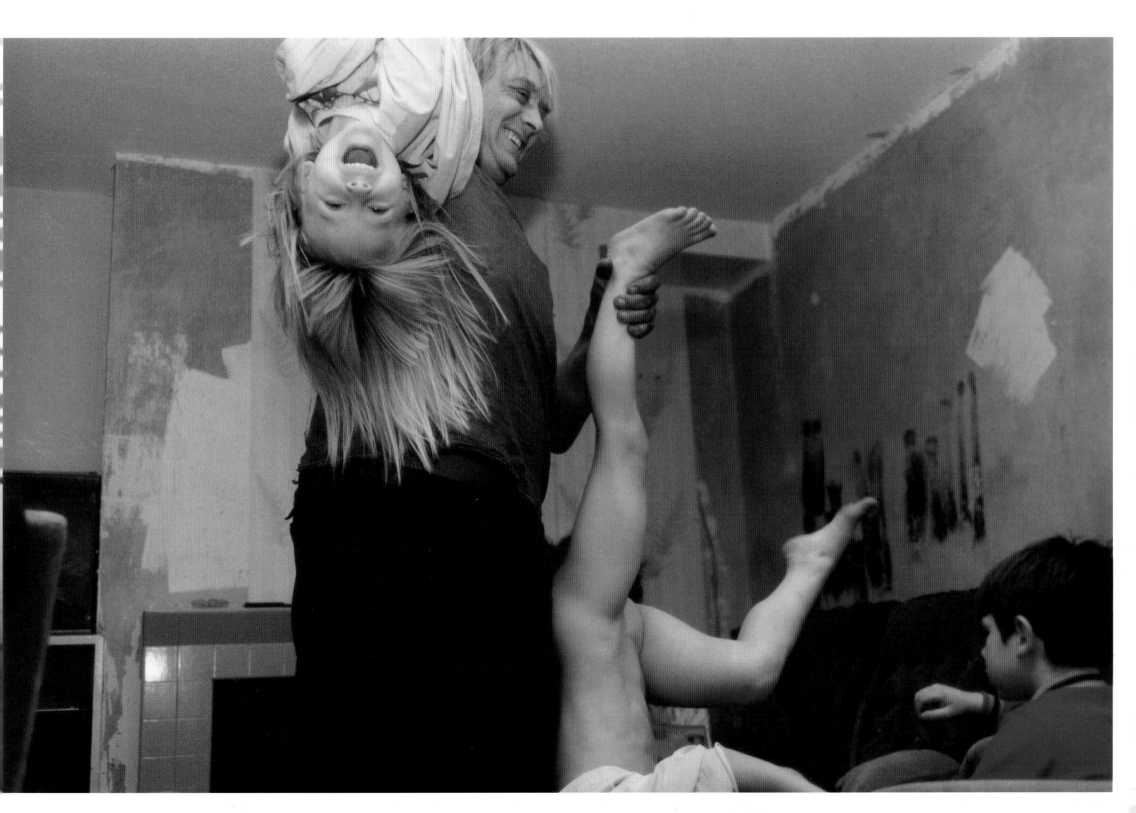

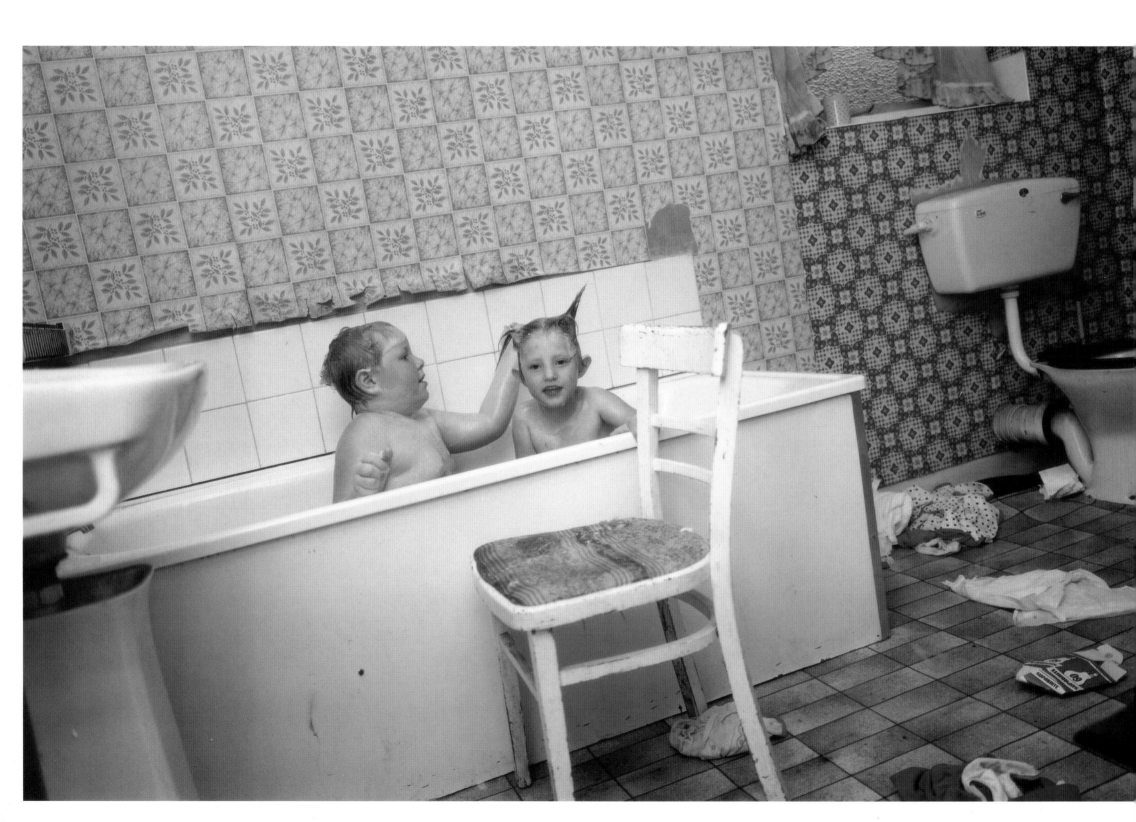

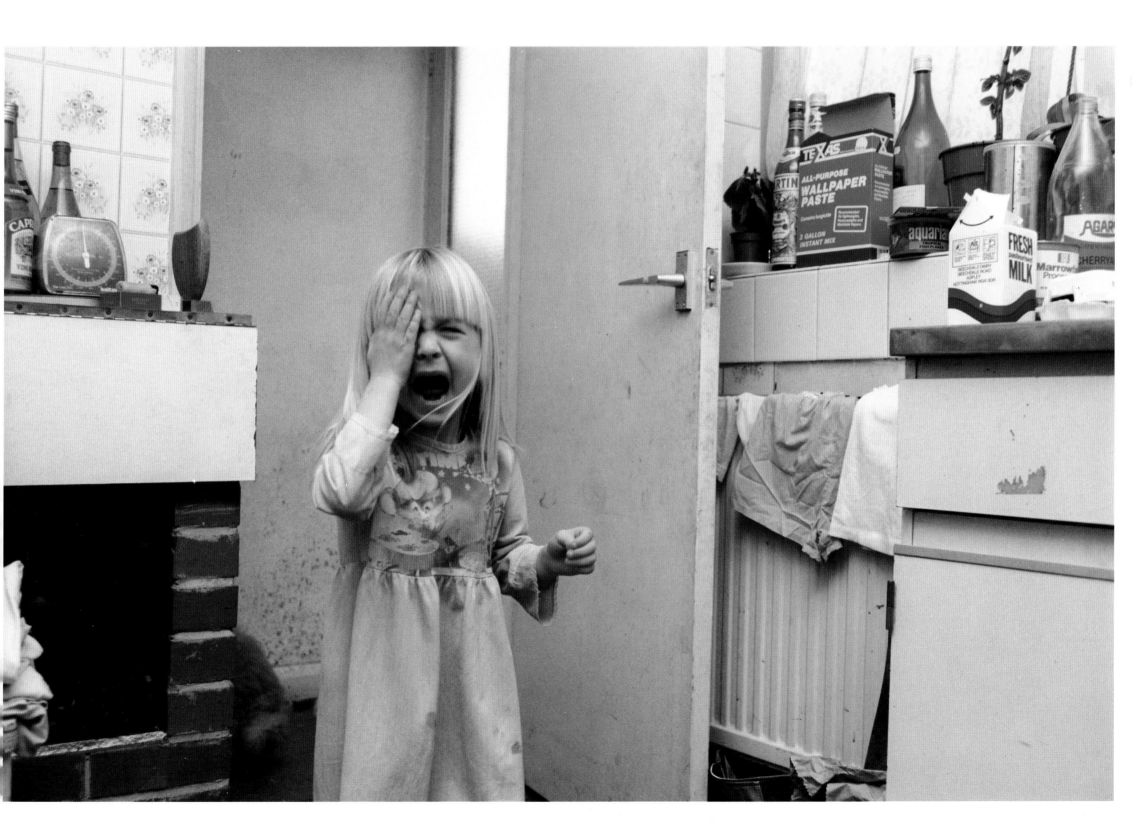

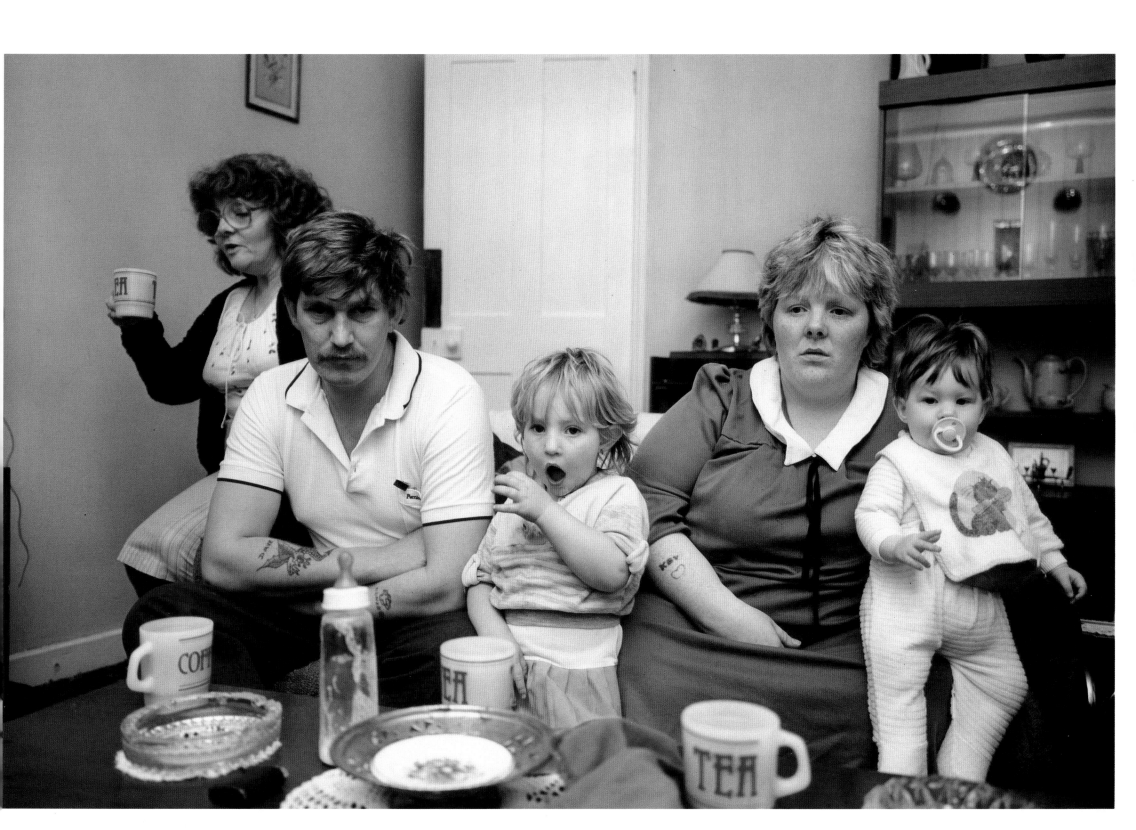

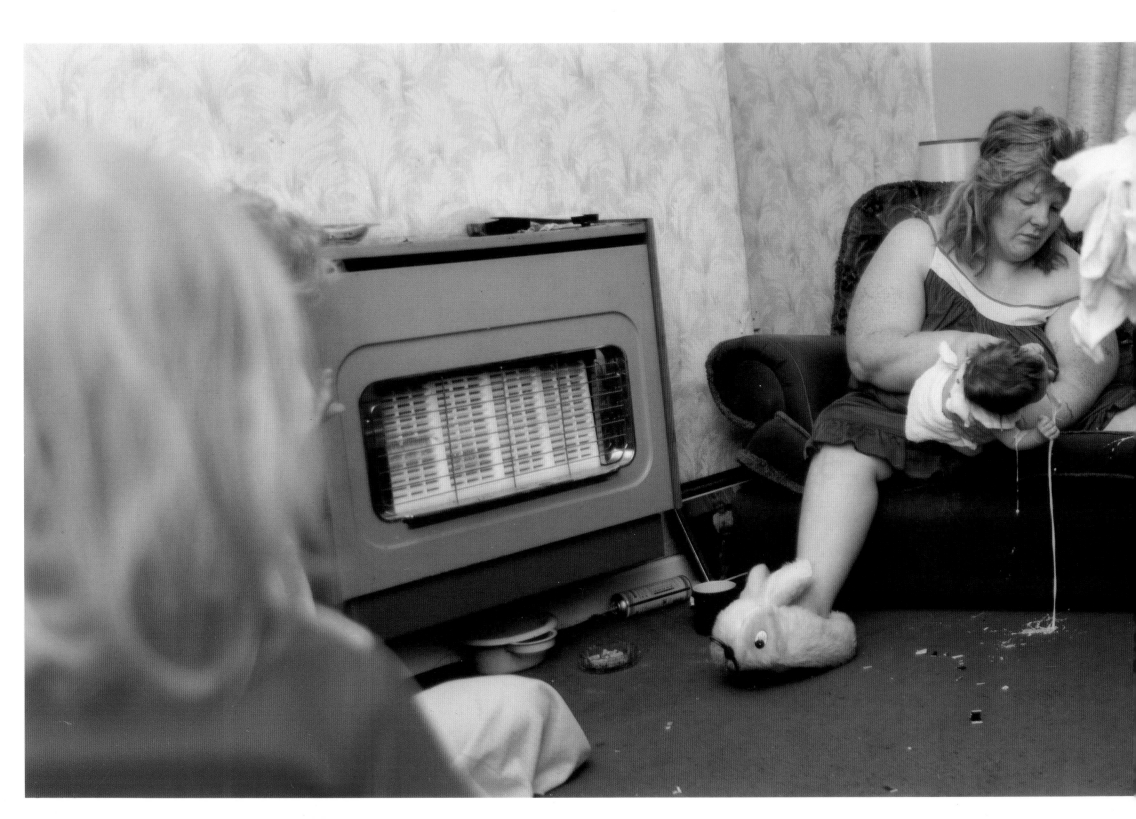

Comments

I knew I was lying. Among the pictures on the school table, I had found a thrilling color photograph by one of the students: three demonic little girls in plaid dresses, Hoovering the lawn. "Whoever made this photograph has found his eyes," I said. "If he pays attention to the accident of what he's done he can trust those eyes. There's an entire body of work charted in this photograph--the life's work of a completely original and powerful artist."

I was lying because I knew that it would be downhill from there; whoever had made that amazing picture was doomed to a life of descent from that high point. A thick voice, with what I think of as a working-class accent--the classroom was in London--said, "I'm Waplington. There's more in the box."

I put the box on the table. I reached down, and dealt the pictures to the students. I looked, and each one was as clear and as powerful and as sure as the first. Their subject was the lives of families, and no work of fiction that I knew embodied so complicated a picture of the circus of family hysteria: cruelty and bliss, energy and exhaustion, the cycles of appetite--pictures of two neighboring families, smoking and sucking and pinching and goosing and eating, each picture as dangerous and ecstatic as a Bruegel.

And as composed. Hold a Waplington to a mirror, upside down, so that its subject is lost, and the forms alone remain true to the event. They have a nervousness, an imbalance, and yet the center always holds. They are made from the center, inside out. Cartier-Bresson, Robert Frank, Salgado, all compose from a distance--from above, from the other side of the room, or across the street. Waplington is an invisible presence at the hub of his photographs, looking up. It is the point of view of a watchful and tyrannical child; his photographs cage his people in one room, permit them isolation but no privacy. If they go upstairs, alone, he never follows them.

His pictures have the precision of good writing--what more perfect opening sentence for a short story could there be than "Three little girls in gingham dresses were Hoovering the lawn"?--but what they reveal has the precision of dreams. There are ogres, and

Alices on linoleum floors, and enormous mothers who have drunk oceans. His people live in a confined world, but they are all powerful within it. The child with the vacuum cleaner is a giantess of five, who has inherited her father's hands, and his power over his realm. Her smile is unreadable. She is full of purpose as she sucks up the world. It's a riotous world, but one without laughter. Everyone in a Waplington is purposeful, headed in his own direction and fractions away from colliding with other purposes.

All those cross-purposes create a hilarity of incident. Children and slaps splashed across the room; crawling infants, teddy-bear slippers, candy wrappers, vacuum cleaners that come indoors and become hair-raising. And always the sense that each furry-slippered foot can be trampled by any other.

There is a hierarchy within this living room. It begins with the little girls, then reaches to the mother, an exhausted odalisque who rises as a Fury--cutting up Polaroids, forcing on shoes, feeding her family, threatening her husband with a kitchen knife. And then above all the shirtless, beautiful father, with "empty" tattooed on his stomach, throwing his naked daughter upside down with an ardor that will leave all his daughters wild and upside down for the rest of their lives.

Each member of the family believes that he is the heart of the story; Waplington alone is there to record their exchange of roles. The screaming sister at the center of one picture becomes the silent child in the corner of the next. Waplington's families, like Chekhov's, act out every thought or emotion in denial of what they truly mean, because what they truly mean is so dangerous. Their passions are revealed in play, and Waplington's gift is to have perceived that everyone is playing for blood.

The photographer's triumph is to bring order out of chaos, without betraying the chaos. Waplington presents the violence in affection, the sexuality in innocence, a chill at the electric hearth, all in a new vocabulary, without romance, all in the same room at the same time.

Montauk, February 1991

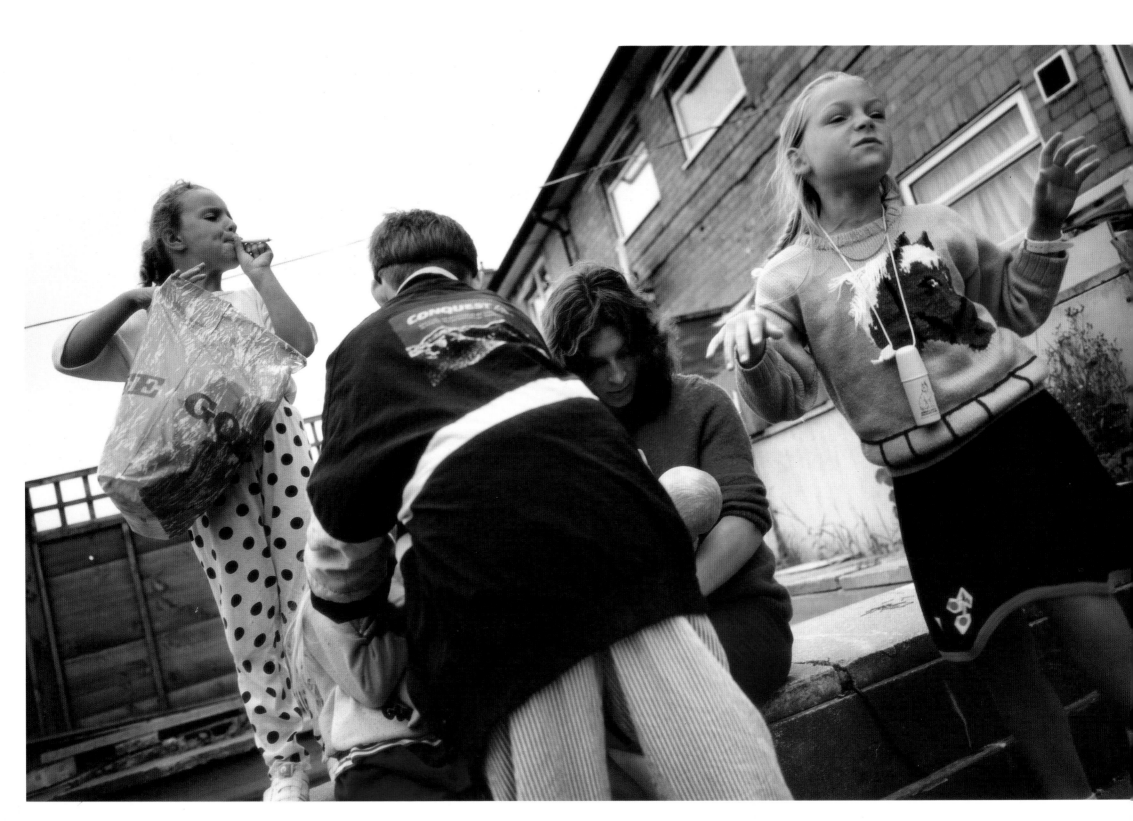

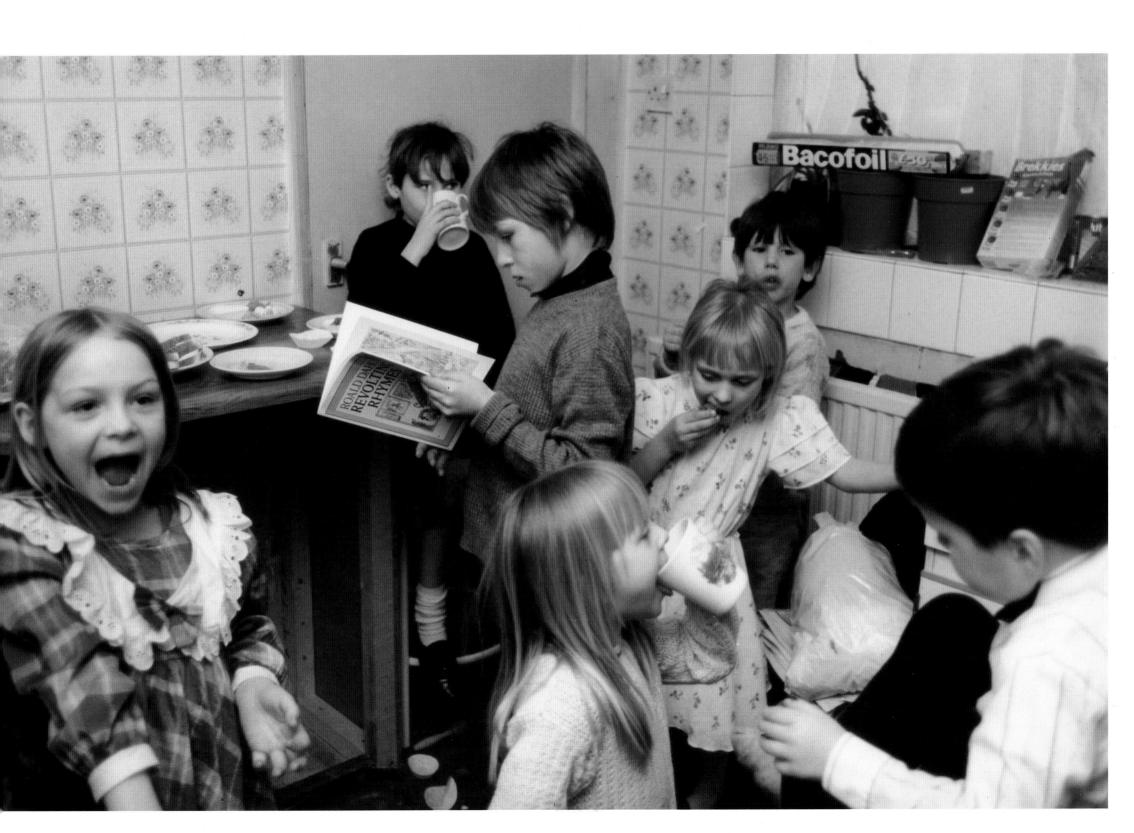

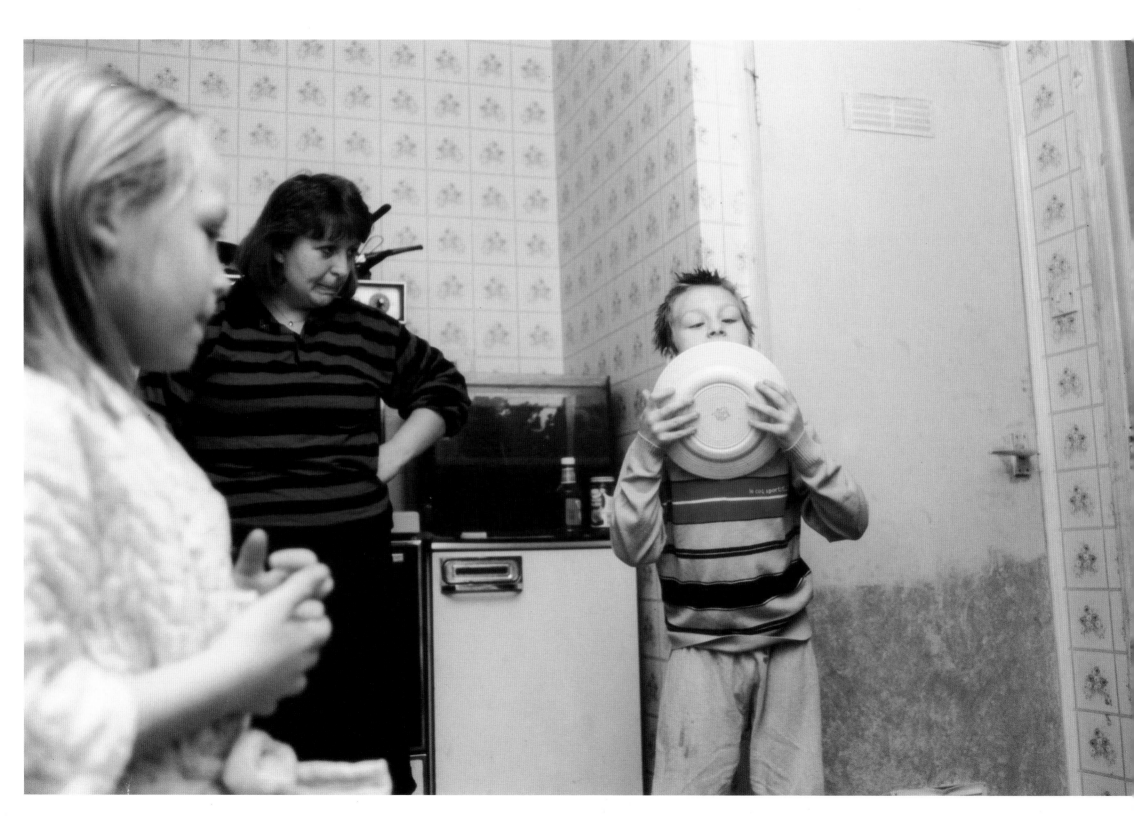

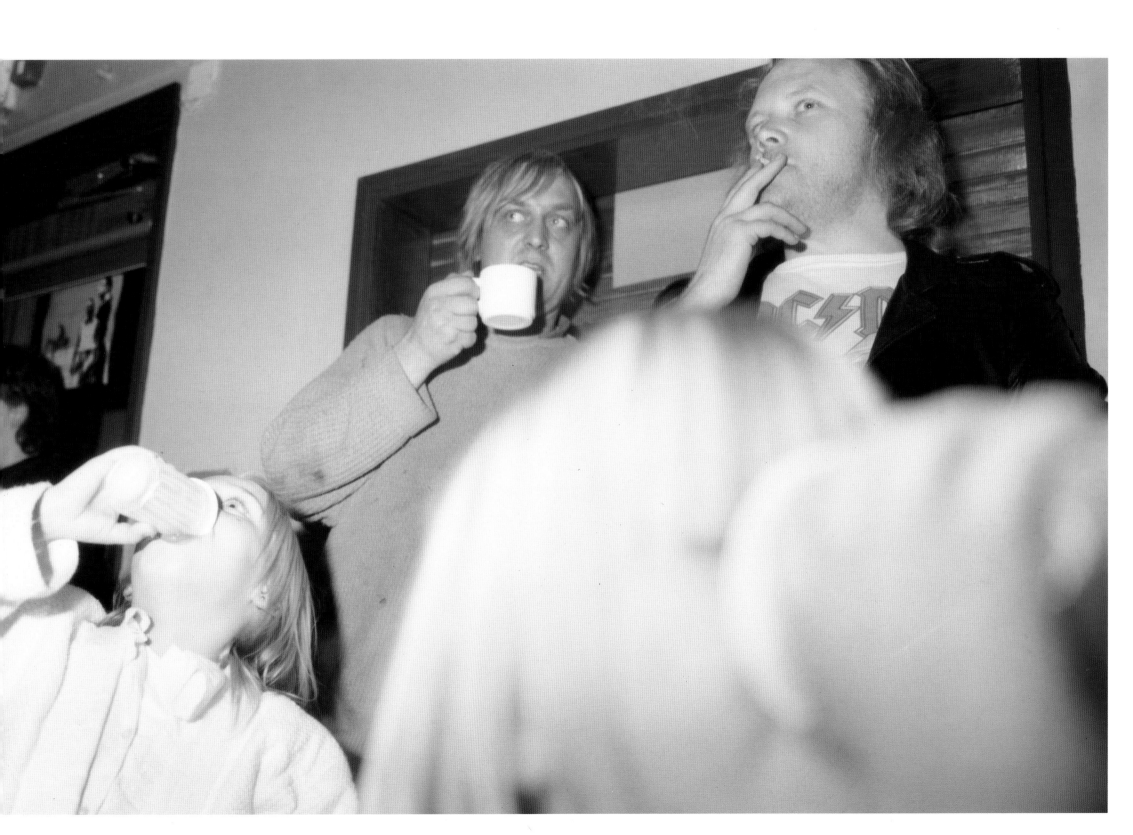

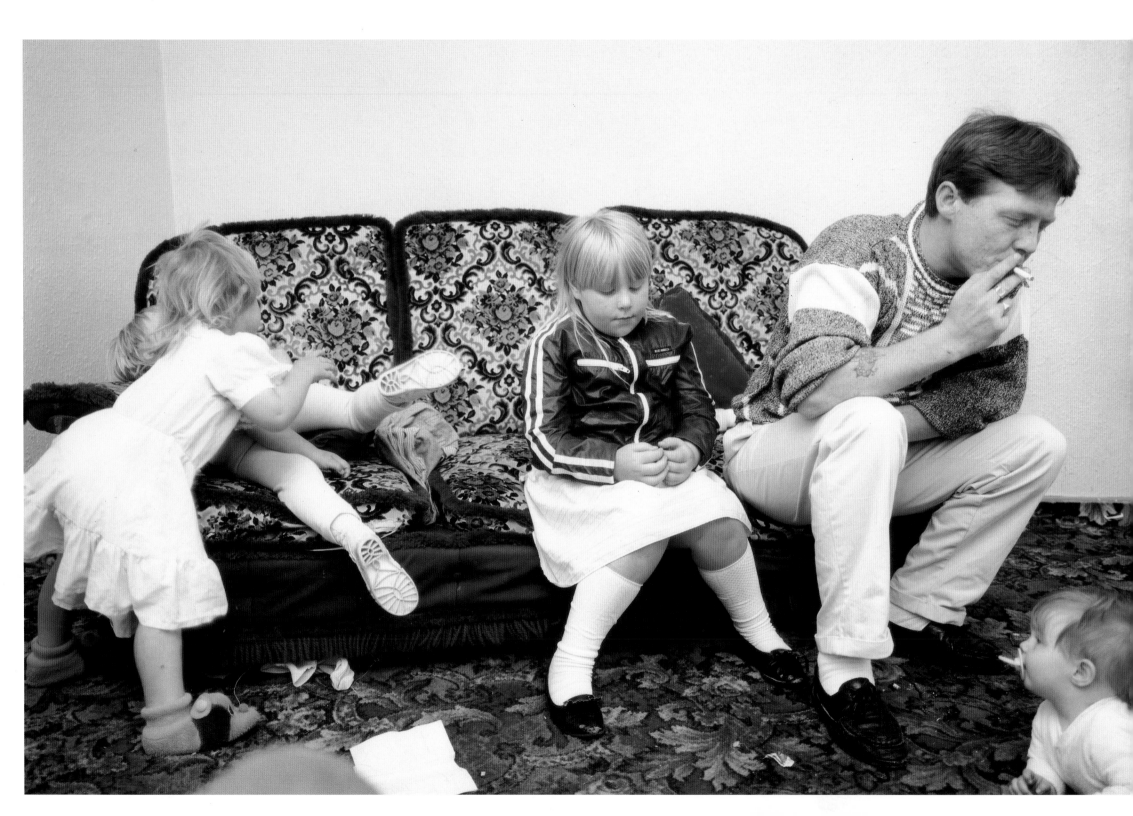

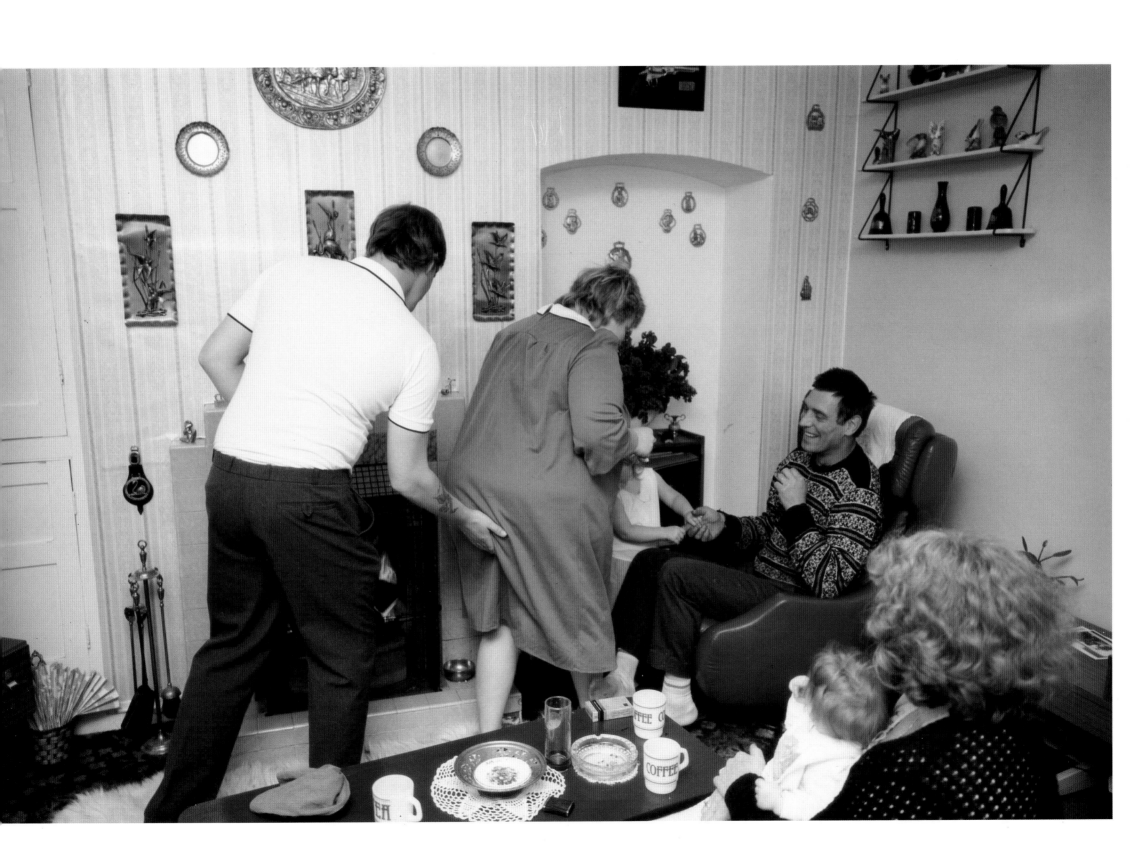

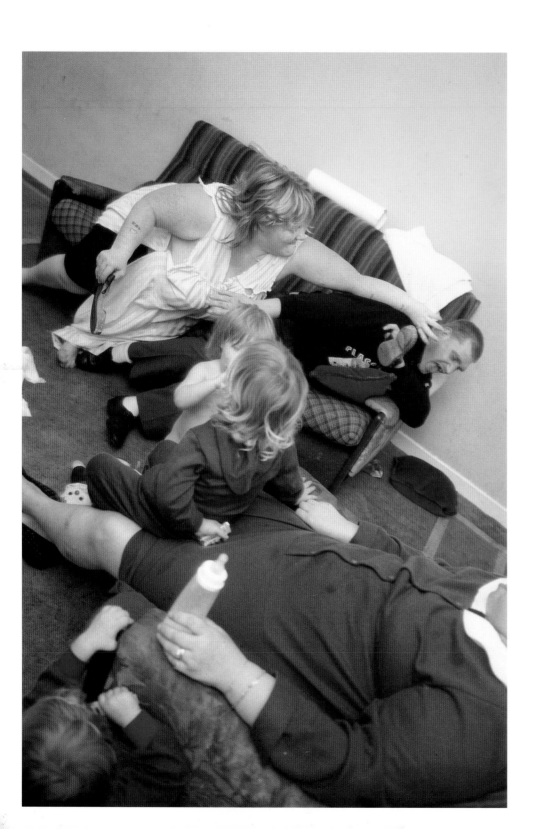

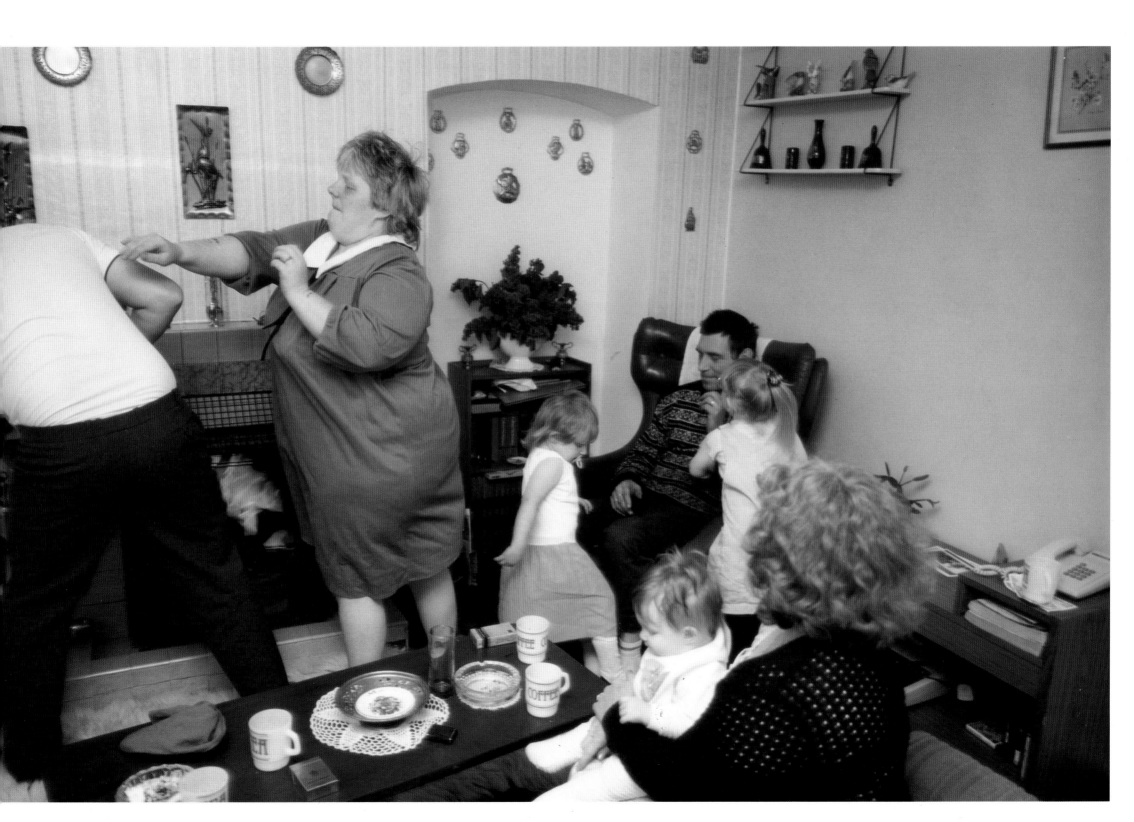

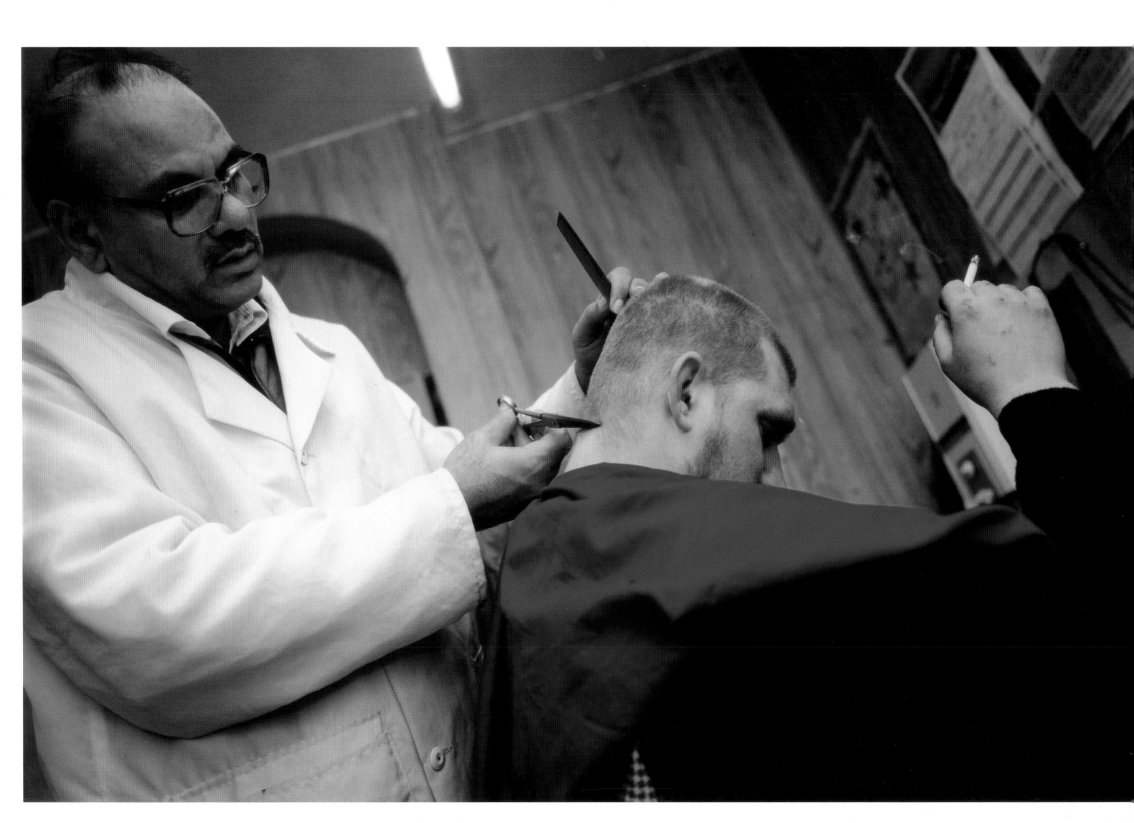

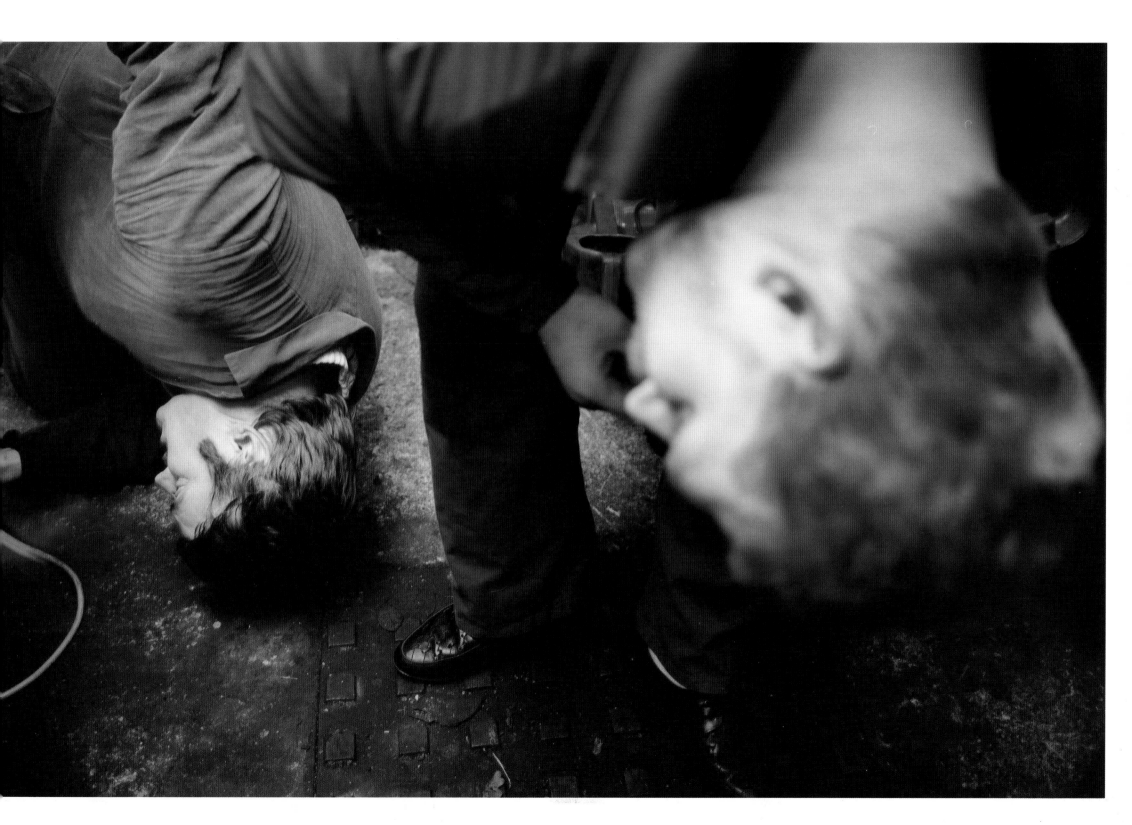

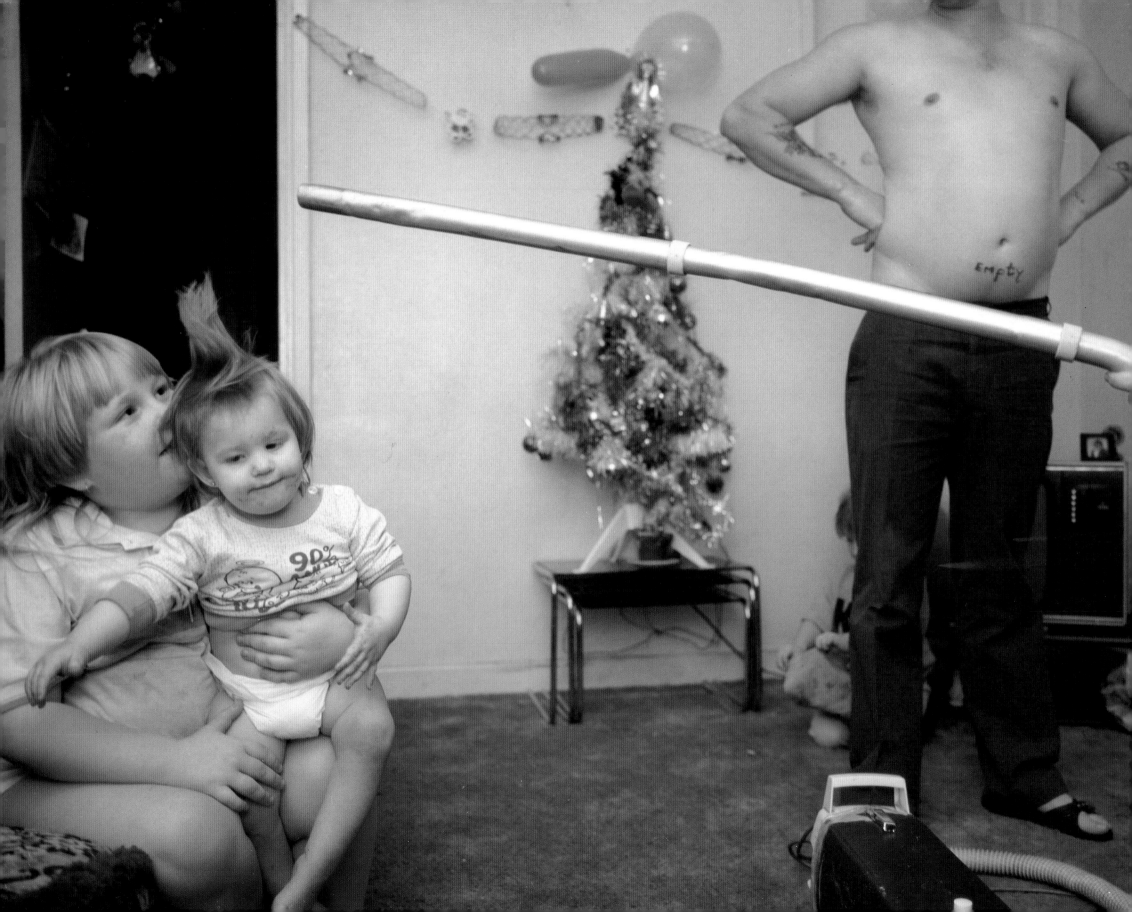

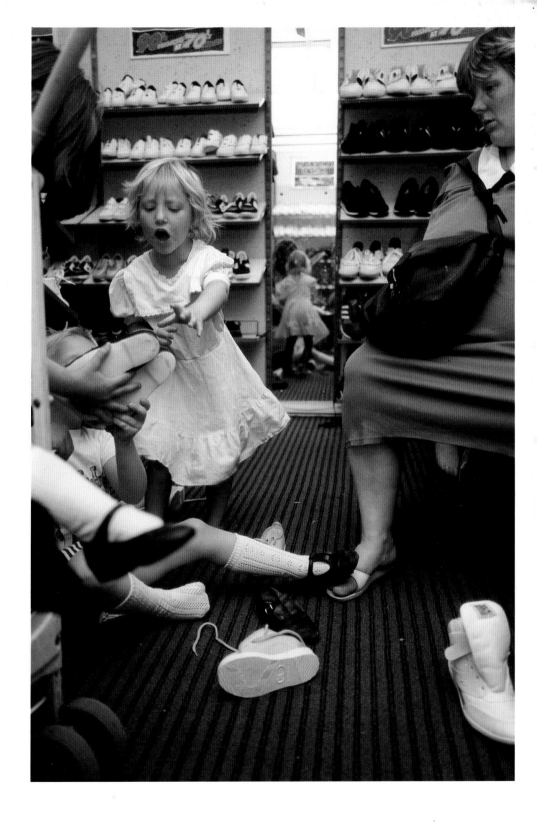

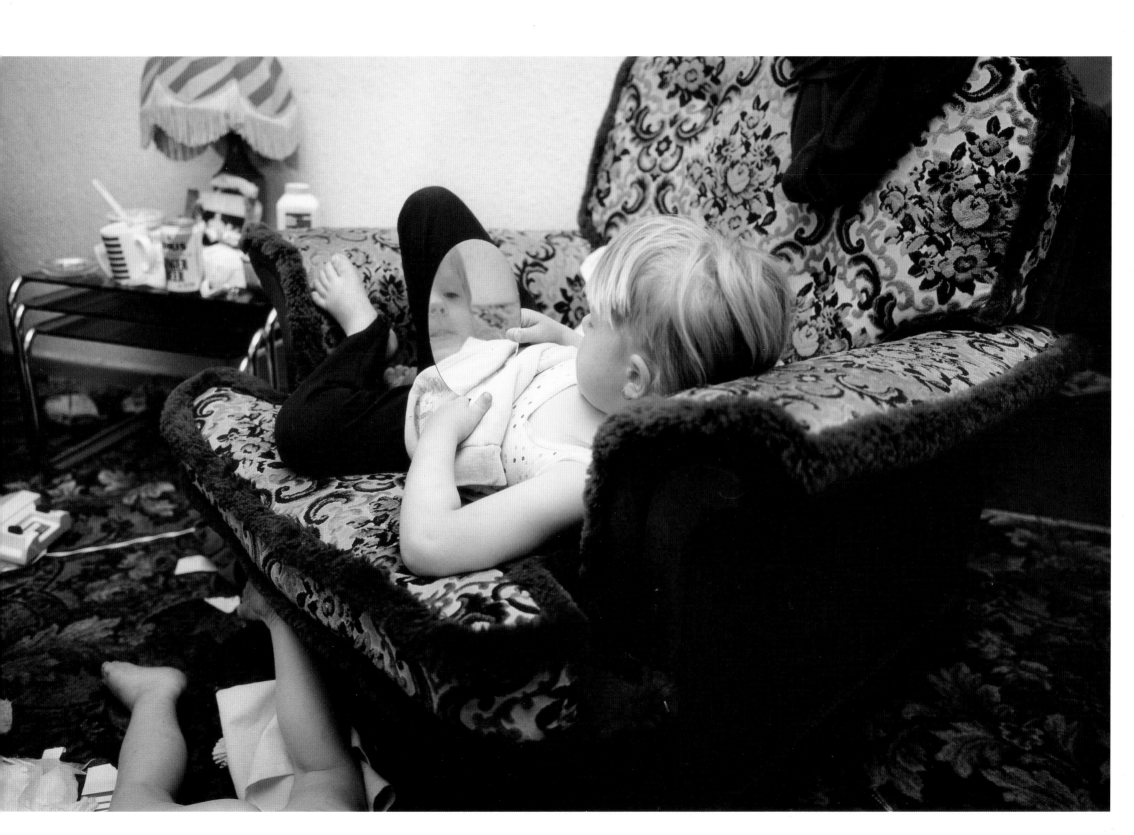

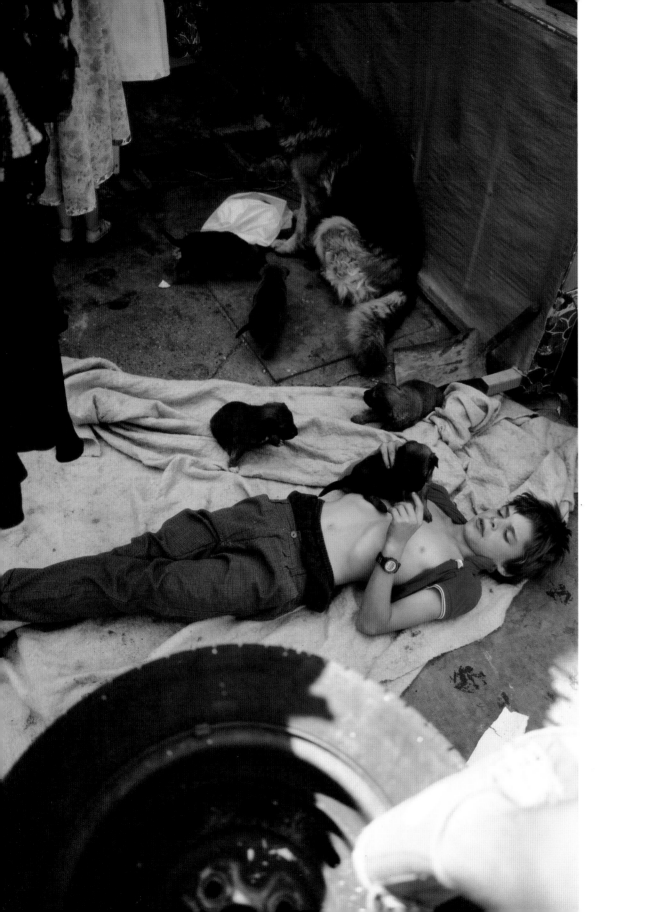

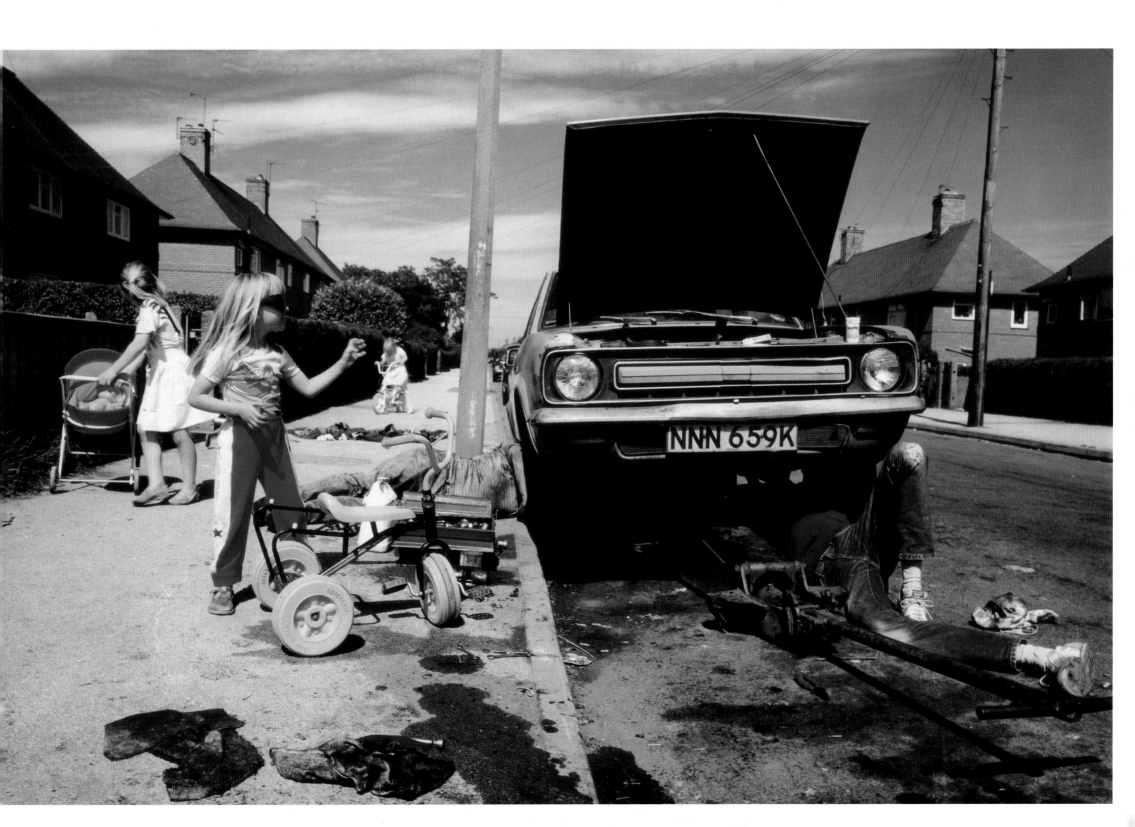

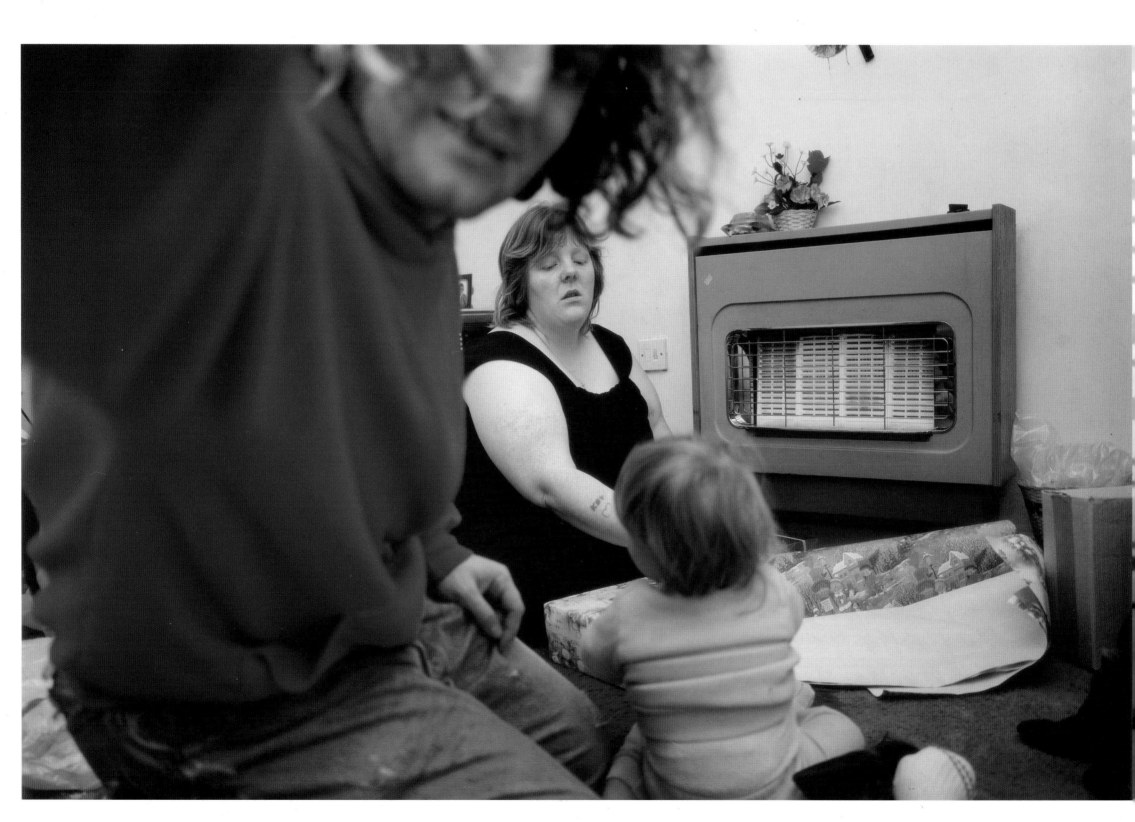

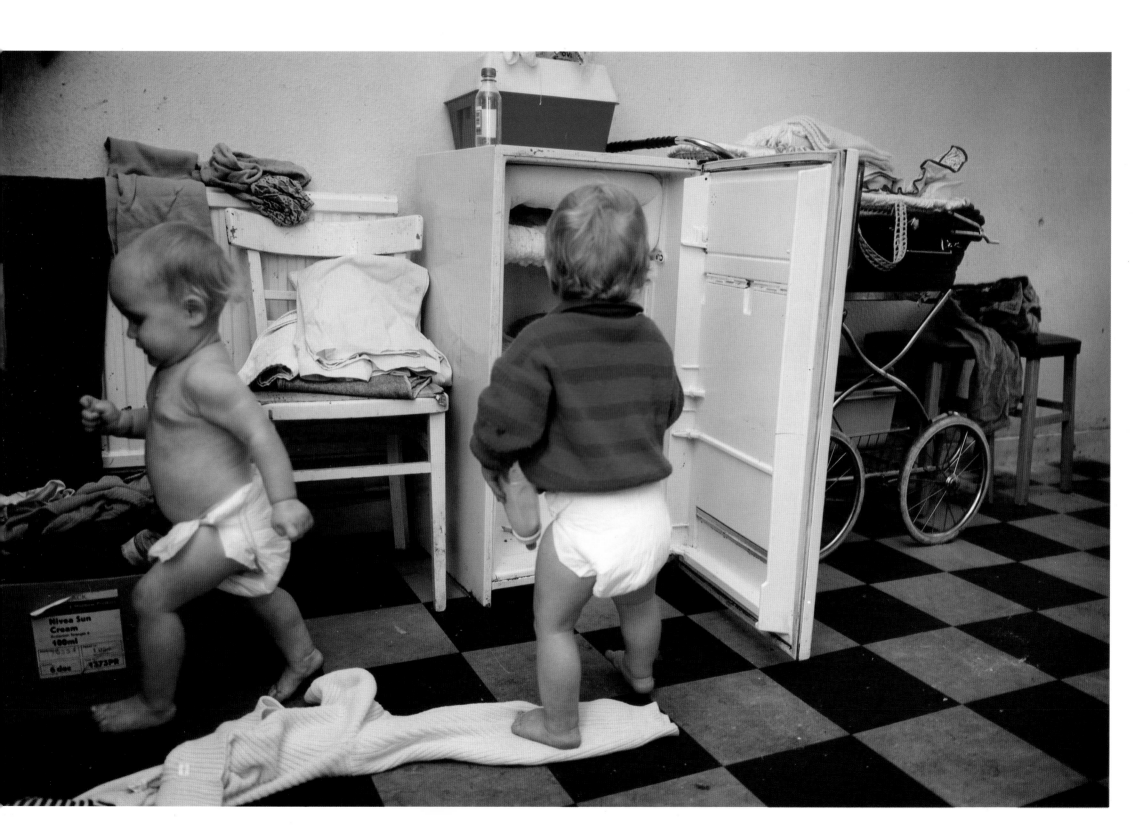

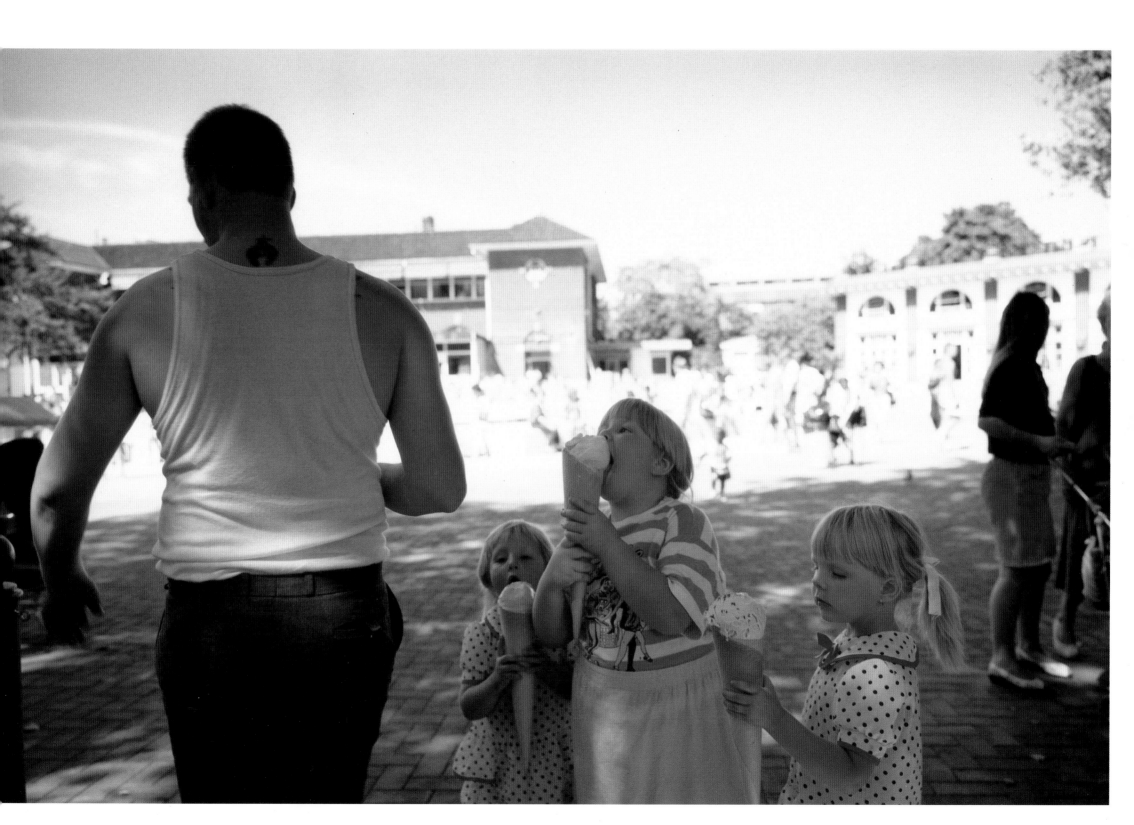

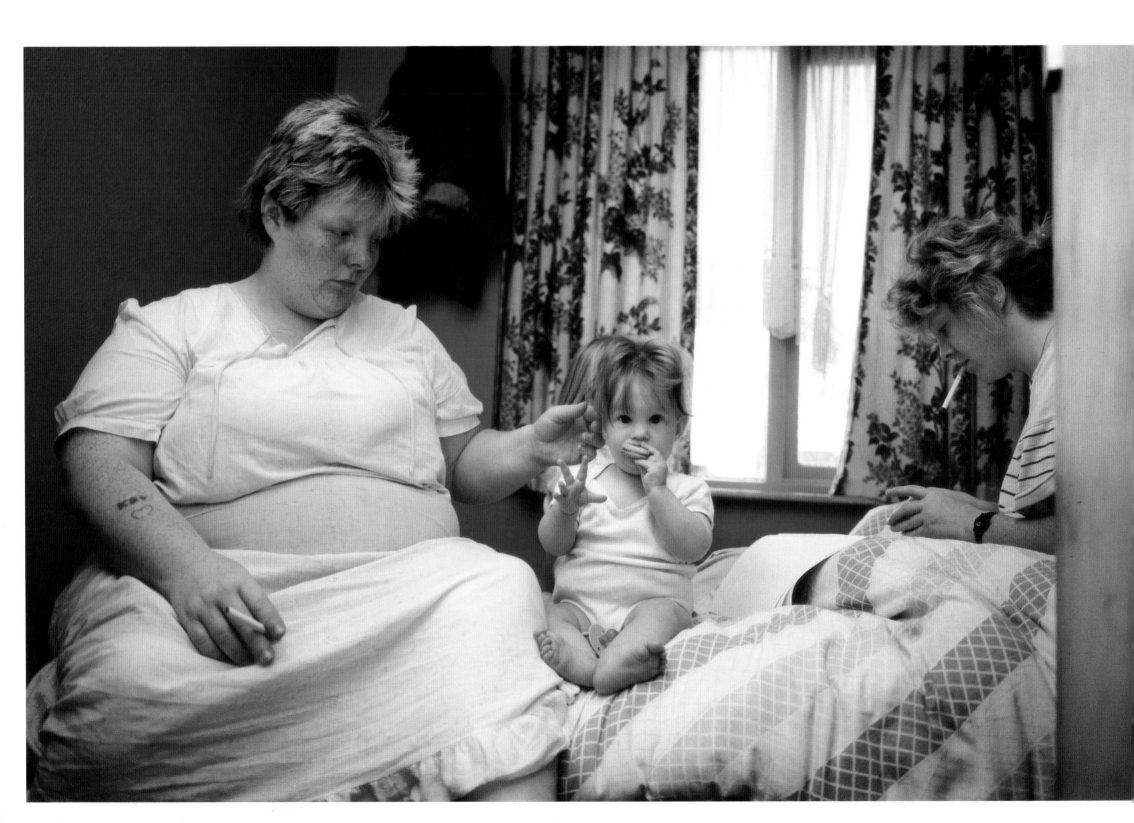

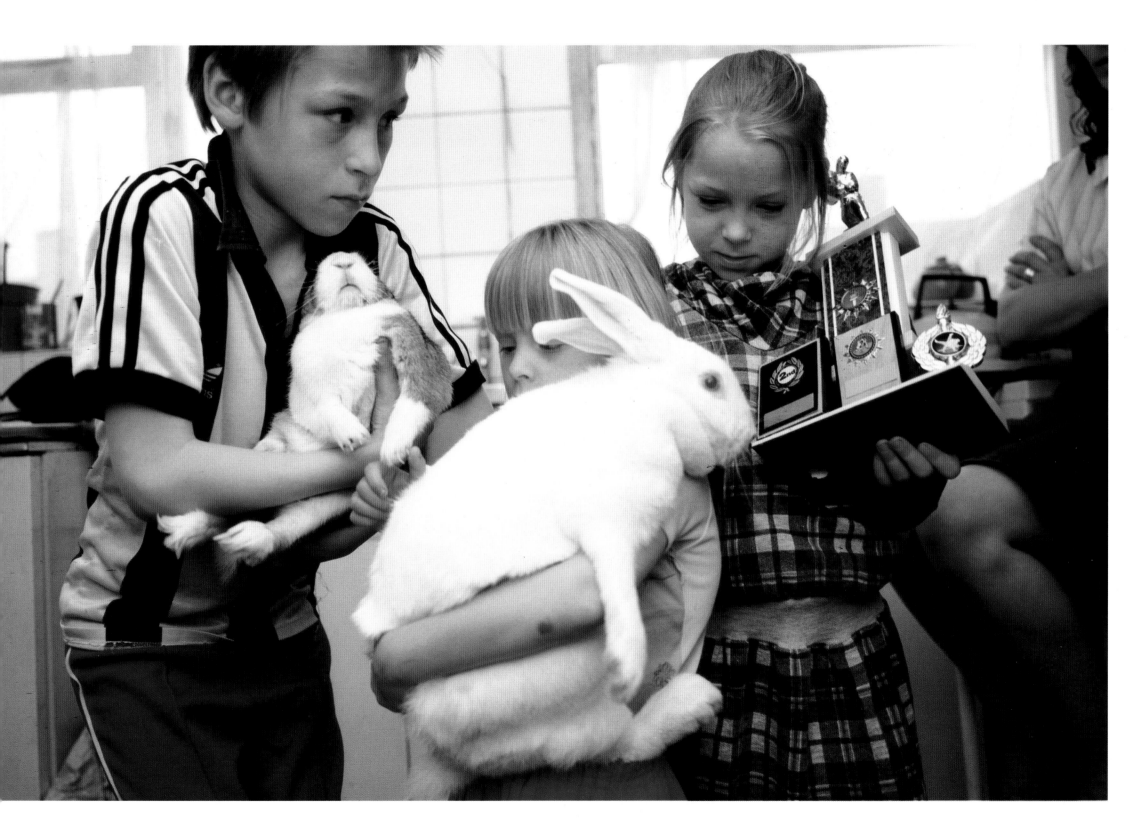

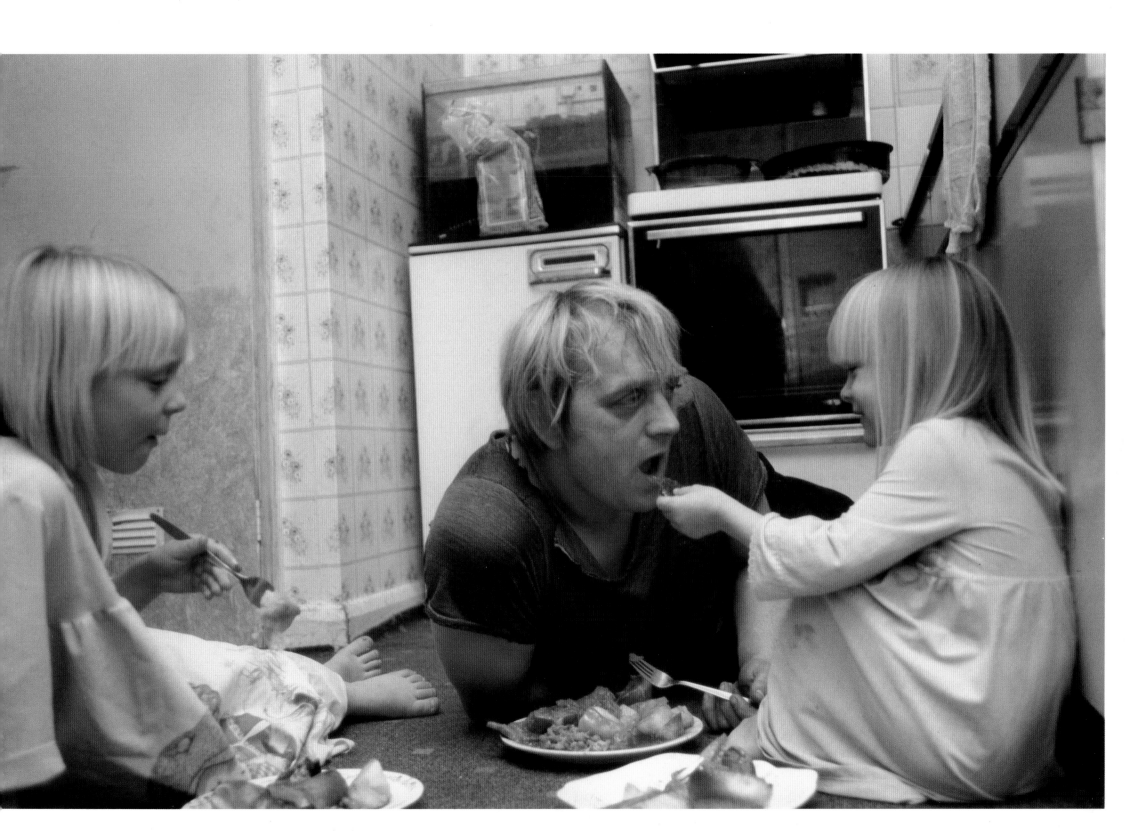

Publication of this work was made possible, in part, by the E.T. Harmax Foundation. Aperture gratefully acknowledges this support.

Living Room will accompany a traveling exhibition by the same name, organized by and opening at the Burden Gallery at Aperture. Copyright © 1991 by Aperture Foundation, Inc. Photographs copyright © 1991 by Nick Waplington. Essays by Richard Avedon and John Berger, copyright © 1991 by Richard Avedon and copyright © 1991 by John Berger. All rights reserved. All rights reserved under International and Pan-American Copyright Conventions. Distributed in the United States by Farrar, Straus and Giroux. Printing, binding, and color separation by Everbest Printing Co., Ltd., Hong Kong. Library of Congress Catalog Number: 91-071318. Hardcover ISBN: 0-89381-481-4.
The staff at Aperture for Living Room is Michael E. Hoffman, Executive Director; Melissa Harris, Editor; Jane D. Marsching, Michael Sand, Assistant Editors; Stevan Baron, Production Director; Linda Tarack, Production Associate.
Nick Waplington's photographs are available in exhibition-quality prints. Inquiries about purchase, exhibitions, and permission to reproduce should be addressed to: Burden Gallery, Aperture Foundation, 20 East 23rd Street, New York, NY 10010; Tel. (212) 505-5555.

Many people have helped me in the last few years--to list them would take a book in itself! But I feel I must give special thanks to Amanda, Richard Avedon and his staff, Roger Beecroft, John and Beverly Berger, Roger Bounds, Christian Caujolle, Mathew Conduit, Mick Finch, Peter Howe, Eastman Kodak, Aperture, my parents, Bill Philip, Mark Power, Martin Schaub, Matt Whyte.
This work was the result of a friendship which goes further than these pictures could ever go. So to Dawn, Jeff, Mick, Christine, Vicky, Dave, Janet, Lisa, Kelly, Melissa and Shane, here's to the future! -N.W.

Book design: Laura Genninger; Art Direction: Tibor Kalman /M&Co. Photographs printed by Nick Waplington and Matt Whyte.